BLACK & WHITE
PIPELINE

BLACK
& WHITE
PIPELINE

Converting Digital Color into
Striking Grayscale Images

Ted Dillard

LARK
BOOKS

A Division of Sterling Publishing Co., Inc.

New York / London

Editor: Kara Helmkamp
Book Design: Ginger Graziano
Cover Design: Thom Gaines – Electron Graphics

Library of Congress Cataloging-in-Publication Data

Dillard, Ted, 1956-
 Black & white pipeline : converting digital color into striking grayscale
images / Ted Dillard. -- 1st ed.
 p. cm.
 Includes bibliographical references and index.
 ISBN 978-1-60059-400-7 (978-1-60059-400-7 : alk. paper)
 1. Photography--Digital techniques. 2. Black-and-white photography. I.
Title.
 TR267.D548 2009
 778.3--dc22
 2009014894

10 9 8 7 6 5 4 3 2 1

First Edition

Published by Lark Books, A Division of
Sterling Publishing Co., Inc.
387 Park Avenue South, New York, N.Y. 10016

Distributed in Canada by Sterling Publishing,
c/o Canadian Manda Group, 165 Dufferin Street
Toronto, Ontario, Canada M6K 3H6

Distributed in the United Kingdom by GMC Distribution Services,
Castle Place, 166 High Street, Lewes, East Sussex, England BN7 1XU

Distributed in Australia by Capricorn Link (Australia) Pty Ltd.,
P.O. Box 704, Windsor, NSW 2756 Australia

If you have questions or comments about this book, please contact:
Lark Books
67 Broadway, Asheville, NC 28801
(828) 253-0467

ISBN 13: 978-1-60059-400-7

For information about custom editions, special sales, premium and corporate purchases, please contact Sterling Special Sales Department at
800-805-5489 or specialsales@sterlingpub.com.

BLACK & WHITE PIPELINE
by Ted Dillard

TABLE OF CONTENTS

BLACK & WHITE PIPELINE

About this Book:

I t's one thing to talk about writing a book on black-and-white photography. It's something else to actually sit down and start putting it together. Images of Minor White, Fred Picker, and Edward Weston came floating through my dreams. I heard the words of my grandfather, working in his darkroom; I remembered learning to take pictures and process them from my father. Even "Saint Ansel" himself made an appearance—Ansel Adams is generally credited with the development of the legendary Zone System, a method to visualize and thus control the contrast and density of a negative using a balance of exposure and development. Above all, I hear the words of a good friend and fellow photographer Steve Marsel saying, "If you're going to write a book, say something. Make it helpful. Don't waste my time."

This book is about developing a process; it is about understanding the basic nature of the black-and-white photograph, and finding a way to achieve the best results with the simplest, most elegant solutions—for you. The first step is to understand what makes a black-and-white photograph.

The Paradox of Palette: Black-and-White Digital Photography

Art, for all arguments and discussions, is about expression. Artistic expression throughout history is as linked to the medium as it is to the artist. Even if we look back to prehistoric artists, making images of animals on caves in Lascaux, the work we see is a melding of the artist's vision and the tools at hand. The beauty found

in these primitive cave paintings is not only about the colors and forms—it is about the ability of the artist to express these forms, feelings, and sense of the subject using the simplest tools and pigments.

I have a favorite story about Pablo Picasso. The story goes that he was living in Paris, and for a while was short on money. He had developed a following, and he could sit down in a café and pay for his meal by dashing off a simple drawing with a pencil on a scrap of paper. Picasso was, among other things, a master of line. I can only imagine those sketches—I'm not sure if any survived, but I have been fortunate enough to see (and photograph for the collector) Henri Matisse's personal collection, including some very personal drawings by Picasso, almost

nothing more than doodles on the back of a finished work. They were beautiful in their innocence and simplicity, but also their expression. These works possess an undeniable mystery precisely because they are so compelling and expressive. Four simple lines on a piece of paper can elicit the beauty and mystery of the human form.

The black-and-white medium was the essence of photography for a very long time. It may be surprising to learn that the first known permanent color photograph was taken by James Clerk Maxwell as early as 1861—a mere 40 years after Joseph Niépce created the first photographs. It wasn't until 1935—and the introduction of Kodachrome—that color became a viable, popular medium.

Black-and-white photographs as fine art are often distinguished as "expressive," "sensitive," and "creative." Why is this? It is the limits of the medium and the photographer's ability to work within those limitations to express a vision. Much of the power of a black-and-white image lies not in its representation of reality, but in its interpretation of reality at the hands of the artist.

And here is the first rub in photography: Photography, especially color photography, is commonly described as realistic. Colors are said to be "lifelike," "true," and "real." An image is often trusted—and, I would argue, mistrusted—to be a representation of reality. Right there is the issue with photography as fine art: If a medium is reality, then how can it also be an expression of the artist's vision?

By its very nature, black-and-white photography neatly skirts this issue. The fact that a black-and-white photograph represents colors with shades of gray makes it an interpretation, rather than a mirroring, of what the artist sees. It is the simplification of the palette and the limitations of the medium that give the image its power of expression.

Take this one more step, into the world of digital photography. We now have a tool—Adobe Photoshop—that has almost unlimited power in producing images and effects that mimic and recreate "reality." We are able to create

photographs with as much color depth as our eyes can perceive and print them with a larger range of colors (or gamut), more than we ever could achieve in the traditional darkroom. We can record the world with astounding fidelity.

One of the beautiful things about digital photography, and the RAW file in particular, is that our creative process has shifted more to the act of combining pieces of an image rather than capturing the image, the negative, and working with what you've captured. I can make a digital photograph in color and reproduce it in color, black and white, or any other interpretation of that original image by manipulating the RAW file.

Throughout this discussion of the various techniques and processes of digital black-and-white photography, you're going to have to decide exactly how much you want the medium to limit you, and how you'll use that limitation to fulfill your vision. Whether you shoot in full color and control the image throughout the RAW process and subsequent image adjustments, or you use a camera that can only shoot in black and white (a "dedicated grayscale" camera), you will learn to harness its limitations. It's a decision you have to be aware of, learn about, and make for yourself.

BOOK 1:
BASICS OF DIGITAL BLACK AND WHITE

Mastering black-and-white photography is about learning to see in shades of gray. Unlike color photography, the photographer is not taking photographs of what the eye sees—the vibrant, rich colors of the world. Instead, the photographer is taking photographs of what the mind's eye sees—the luminance of the world represented by tones varying from white to black. The black-and-white photographer is a musician, transposing notes on the fly, visualizing a final print from the world of color.

This can only be learned through two methods: creating a process and using the same system over and over until the process becomes reflex. Only then can the mind see what the process will produce.

We're going to start with a general overview of the black-and-white digital process, and then break down the pieces of the process to see how they fit together. From there, we'll see how to create a custom process: a system that fits your work and your way of working.

The most important place to start is with the simple but profound difference between the traditional darkroom workplace and the digital workspace. Rather than the artist learning to work within the discipline of a medium and the limitations of materials like film and chemistry, the digital artist employs another form of discipline to build a process. In the limitless world of digital imaging, digital artists must use discipline that comes from within.

CHAPTER 1:
PROCESS, LUMINANCE & COLOR

The Importance of Process

When you're driving your car, do you consciously think of where your hands are or what your feet are doing? How about riding a bike; are you aware of how you stay balanced? If you play a musical instrument, are you thinking of where your fingers are, what they are doing, and what you have to do next?

Of course you don't. Much of what we do automatically is considered routine. As a result, we're able to do one thing while thinking about something else.

Working in my old darkroom was like that for me, and loading sheet film into film holders is a good example of how a task can become routine. It is a delicate task that must be done in complete darkness.

Any number of things can happen. You can knock stuff over when reaching for something. You can lose something in the dark. You can get interrupted and lose your place in the process. The system I had in place to avoid this confusion was based on placement and position. If a film holder is there, it's empty. If it's over here, it's loaded. My sheets of film are rotated to place the notches up and to the right, my film holders are positioned so that the slot is up.

After a few thousand sheets of film, you don't really give the process much conscious thought.

However, you should know that this is coming from a man who shot the same film and processed it in the same developer for over 30 years: Tri-X film, developed in D-76 at 70°F for seven minutes with a one-minute agitation. Boring? Yes. Predictable? Absolutely. Here's the point: For some reason, it is difficult to get to that state of routine when working with digital

images in Adobe Photoshop. In many ways, Photoshop defies attempts to standardize a process. There are so many tools, so many tips to read, and endless methods to achieve the same result. It seems that just when you start to form a habit, there is an update that expands your abilities, increases the power of a tool, and maybe even demands that you relearn entire parts of the process. It isn't easy in the digital darkroom, not because of your digital darkroom's limitations, because it's almost unlimited.

In spite of this (or maybe because of it), the single most important thing you should do is standardize your process. Establish habits that limit you to a few powerful tools and eliminate those that distract you. My friend Nick calls it "going down the rabbit hole," but it happens every time you read an article on some new way to sharpen, rescale, or adjust an image, or in the case of this book, to make a black-and-white

photograph. You read something new, decide to give it a try, and you're off on a new path to a different process. I'm not saying you shouldn't learn or look for better ways; I am saying that at some point you have to make a decision to work out a process for yourself and stick with it.

My process is based on RAW files, layers and masking, and Smart Objects. Your process may be based on making adjustments to the file in Photoshop with layers, plug-ins, or filters. There is no single right way. There are certainly some methods I feel are wrong, but ultimately you must find some way and call it your own.

Once you settle on a process, you can start to build habits and skills. You will work faster and cleaner when you're not wasting time hunting for tools, looking for instructions, or trying to remember a tip you read on a forum somewhere. Once you establish a process, you can evaluate new tips and tricks to see if they're worth consideration, or if they just add an extraneous step in your process. With a process in place, it's easy to try new things in a series of controlled tests.

If you have a well-defined style of photography or a typical particular workflow with which you're already familiar (such as the production line in a commercial studio), for a significant project you're working on, you may find you are using a slightly different process—but hopefully a similar set of tools. When I'm shooting my personal work I strictly use a Smart Object workflow (as described in detail in my book, *Smart Object Pipeline*), but when I'm on assignment and power-processing TIFFs for a client, I may just be slamming out files from Camera RAW. The first steps of my process stay the same—sorting in Bridge and processing multiple files in Camera RAW—it's the end game that changes. The bottom line is that, for me, the Smart Object workflow is a remarkable tool that can accomplish everything I need to do.

The key is to understand what the best tools are for you. What works with your style? What feels natural to you? Do you really understand what you're doing? Know your choices, pick a few good ones, and stick with them.

Understanding Luminance

The keel of a boat is the center timber, the spine from which the entire boat is built. It's the strongest and biggest timber in the boat and is often placed where the boat will be launched, with the entire boat constructed at the edge of the water. In black-and-white photography, luminance is our keel—the foundation on which our entire

process is built—and it extends throughout the process. It starts with the way our eyes perceive light and how our vision interprets the photograph we want to create, continues when we shoot the image and manipulate the luminance of our colors in Photoshop, and is realized when we create the final print. Understanding luminance throughout the process is the key to understanding the process itself.

Luminance is defined as a measurement of light intensity. More strictly speaking, it is a photometric measure of the luminous intensity of light in a specific direction. In practice, luminance is used to describe our perception of the brightness of light or the intensity of light seen with the human eye. As with so many terms in photography, luminance will have slightly different significance as we work with it throughout the imaging process. We use the term to describe how we see the subject, how our monitor displays the brightness, how much light the print reflects, and how paper reflectance and image tones influence how we perceive a print. The term is the core of the black-and-white process.

One of the most important places where luminance plays a major role is in the conversion of color information into grayscale information. The color of the light is a major factor in how you decide to translate color into gray tones.

When you visualize what a colorful subject will look like in black and white, how do you translate certain colors? When you see a blue sky, do you visualize it as medium gray, or do you see deep black, with brilliant white clouds? You're making a conversion in your visualization. The

camera and sensor make a different kind of conversion: using the Bayer array, the sensor takes a measurement from three pixels that translate grayscale values into three colors—red (R), green (G), and blue (B). The pixel on a sensor is simply a tiny light meter covered by a red, green, or blue color filter. When you measure the amount of light hitting the pixel with the red filter, you get a red value for that pixel site. This red pixel information is processed either in the camera as a JPEG file, or from a RAW file through a conversion program (such as Adobe Camera RAW)—another form of translating luminance. In Photoshop you make the conversion from RGB color into a grayscale, single-channel, or a three-channel file where all three channels are equal values (yet another translation of luminance). The printer translates this set of grayscale values from RGB light-generated colors (additive) to CMYK ink-generated colors (subtractive), and is the final translation of luminance.

Controlling the conversions and properly handling the luminance through each step of the process is the key to achieving a predictable result. Predictable results are the key to visualizing a color subject as a grayscale photograph.

To get started, take a look at the Apple Color Picker. In Photoshop, go to Preferences and select "General," then select "Apple" under "Color Picker" (image A). Go to the Color Picker tool on the toolbar (image B). The circle shows "Hue" and "Chroma" (also called saturation). The bar on the right shows you "Luminance." This is slid to the top, maximum value, and if we slide it down

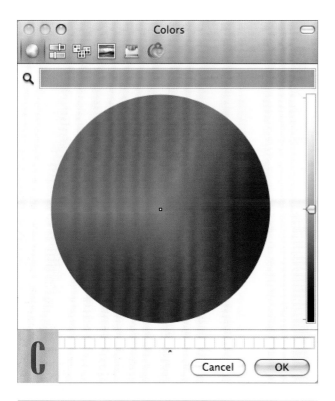

we're going to get neutral gray (image C). Take the slider to the bottom and you have black (image D). As long as the point is in the center of the Hue/Chroma circle (meaning without hue), you get a neutral grayscale. Every color can be described this way, and luminance is an essential part of this description.

Understanding Color

It is very important to start with a basic explanation of color using the luminance, chroma, and hue model. There are a number of ways that scientists describe color, but this model works best for us now because we need to understand luminance.

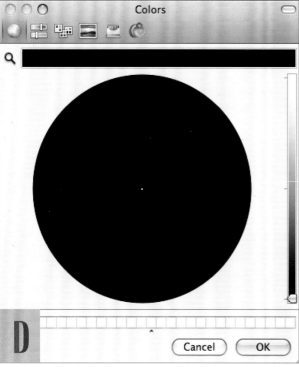

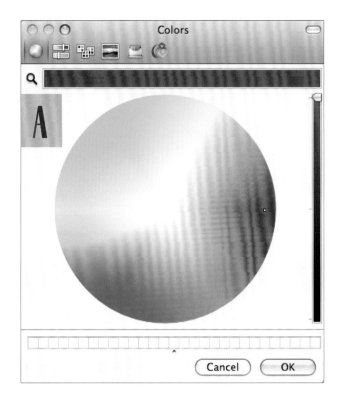

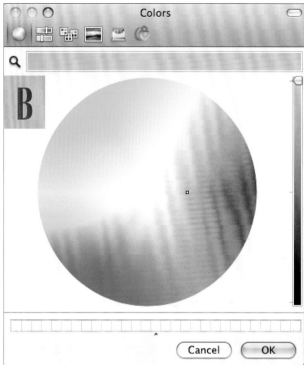

Refer to the Color Picker tool again (page 23) and take a look at what happens when you move a color to grayscale. The first figure (image A) shows red at full luminance. Chroma is often referred to as the color purity, or how "not white" a color is; in this example, the red is almost fully pure. In the second example (image B), the color is moved closer to the center, towards white, and it is more of a pastel red. Note that the hue is the same—it's the same "color" red—with less chroma. If I take the luminance down, it will approach, and eventually reach, black. With the same chroma, same hue, and less luminance, we get rosy gray (image C).

Take a look at the red at full luminance again, and see what happens when we turn it into a grayscale tone. We start with the same red on Color Picker. I open up the Hue/Saturation adjustment layer and simply turn the saturation down to nothing (image D), and I get gray. (Note that the Hue/Saturation tab has the same three controls—Hue, Saturation, and Luminance.) Finally, I go back to Color Picker and sample the gray, and I get a very dramatic move

(image E). The hue and chroma shift into the center of the circle, which is something we expect. The luminance, however, takes a dramatic drop from the highest value to a middle value.

Photoshop calculates this red into a gray value it thinks will match the luminance our eyes perceive when we see that red. This is the crux of the grayscale conversion process: Precisely controlling how a color is translated into a gray value.

The process of translating color—taking all the vibrant colors of our world and deciding how each hue and shade is represented on a scale of gray—is the process that has defined black-and-white photography from the beginning, and is

based on translating luminance from color values to gray values. Digital photography has allowed us to control how every color is mapped to gray. Keep this in the back of your mind as we explore the various methods of creating a rich black-and-white photograph. If you understand how luminance is translated, your final image will be very close—if not identical—to your initial photographic vision.

CHAPTER 2:

GRAYSCALE CONVERSION METHODS

The question I hear most frequently from people working with digital black and white is, "What is the best way to convert from color to black and white?" Like so many things about black-and-white photography, this is a simple question with a complex answer.

All of the grayscale conversion methods I cover in this chapter can be integrated into a larger black-and-white imaging process, but some are more flexible than others. I begin with familiar and very basic conversions and move toward the more advanced techniques. The advanced methods are not necessarily harder—they are simply higher quality methods that require a bit more attention.

Mode>Grayscale Conversion

This is where most people start: Go to Image>Mode>Grayscale (image A). Photoshop automatically takes the three-channel RGB image, maps the colors into a single gray channel, and assigns a default grayscale color space. (You can read more about Color Settings on page 65.)

That's great—it's even easy—but you have no control over how Photoshop maps the colors.

Mode>Grayscale uses a very specific method to take all the colors in the big RGB color space and map them to a grayscale space, and it makes these decisions based on a mathematical model that mimics the human eye (or what they think the human eye sees). This grayscale method uses a formula based on averaging out the luminance values of the three RGB values, but it doesn't do this equally. The last I checked, this grayscale conversion starts with using 30% of the red channel luminance, 59% of the green, and 11% of the blue, and averages the tones based on those values.

There is a problem with this standard conversion formula. What if you don't agree with those decisions? What if your eye works differently? What if you don't really care about the human eye at all, and it's more important to you to render tones that mimic what infrared film can produce? Or you want to map the gray tones to your very own recipe? The downside to the Mode>Grayscale move is it is a simple, automatic conversion—one that gives the photographer no control at all.

Desaturate

The Mode>Grayscale conversion's cousin is "Desaturate." Go to Image>Adjustments>Hue/Saturation and pull the Saturation slider all the way down (image A). This is the same thing as the Mode>Grayscale conversion, and it has the same disadvantages. (You can make this conversion through adjustment layers, too.)

LAB Conversion

There's another fairly popular method, and that is the LAB conversion. LAB is a color space, just like RGB and CMYK, and contains three channels: Lightness, A, and B. This mode allows you to adjust the separate color channels without affecting the overall image color. If you want to strictly map colors without Photoshop applying a preset calculation, first convert the file to LAB. Image>Mode>LAB (image A); this is the result (image B). I've opened the Channels palette, and it has changed from RGB channels to "Lightness," "a," and "b" channels. If I turn the "a" and "b" channels off, I'm left with the basic Lightness value (image C). This is a purer description of the colors, without any adjustments made by Photoshop, and gives us a bit more control over the actual gray value mapping.

NOTE: Another option is the Gradient Map grayscale conversion (Image>Adjustments>Gradient Map). Simply select Black, White as the Gradient. Same deal, no control. There are about four more ways to do this, none with any particularly better controls.

Black & White Adjustment Conversion

The truth is, Adobe doesn't seem to think a straight mode change from RGB to grayscale is a good idea either. If you do that move, you're going to get the default warning shown in image A. Starting with Photoshop CS3, there is an adjustment called "Black & White" (Image>Adjustments>Black & White), and is also available as an adjustment layer (image B). Here I've opened it as an adjustment layer; I can adjust each basic color—Red, Green, and Blue—plus the secondary colors—Yellow, Cyan, and Magenta—to specify how light or dark I want each to be.

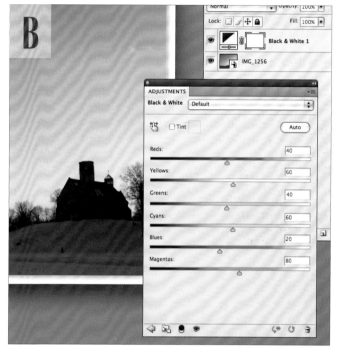

This image has a deep blue sky. When I shot it, I imagined it in black and white, with the most saturated part of the blue sky going almost to pure black (image C). With the Black & White adjustment, I can drag the blue values to get the exact effect that I want. This is one of the things I like about this tool—it's precise and easy to understand. You see a color, envision where you want it on a gray scale, and use the tool to put it there.

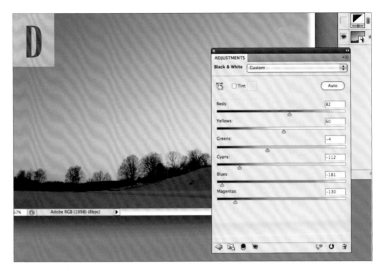

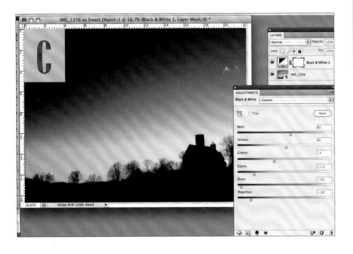

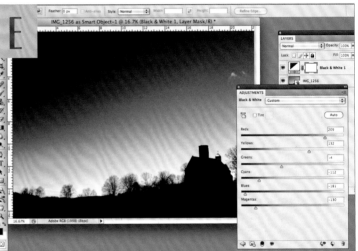

To put an even finer point on the discussion, look at the lower left side of the horizon line. This looks muddy with these settings, and it's basically because it's a reddish-orange color. (Take a look at image D for the color version. I've turned the adjustment layer off, so I can see what color we're starting with.) I go back to

my Black & White adjustment and pull the red and yellow values up. Here's the result of the change (image E)—the skyline is nice and clean, approaching pure white.

Examine the adjustment controls once again. There is a heavy concentration of reds and yellows as the skyline tapers off to blue. To achieve the effect I want, I turn down the red

and yellow, effectively filtering them out. For a photographer familiar with shooting film, this is completely logical. If you were out there shooting it with a film camera and wanted to expose for these values, you would reach into your kit and pull out a Wratten 25 filter—pure red. This would create an image with an almost pure black sky. In spite of years of shooting film, these controls are the first time that filtering has made sense to me.

There are a few other ways to accomplish a grayscale conversion with color controls. One approach, which takes a few forms, is to build a layer that first converts the image underneath to black and white, and then add a layer between the two to control the color the top layer works with. The color adjustment layer in the middle is effectively a filter for color. (This is the "Film/Filter" method. See page 84.) These are work-around solutions, or things we did before we had the Black & White adjustment, and more of a distraction than a real solution.

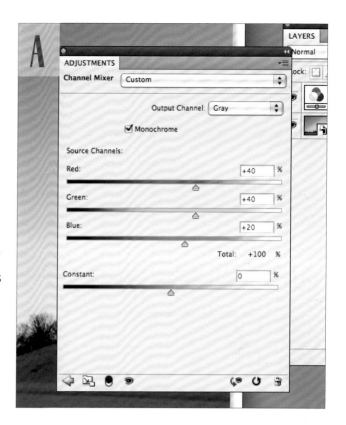

Channel Mixer

The Channel Mixer does exactly what it says: It takes the three channels—R, G, and B—and mixes them into one channel. Take a good look at this figure (image A). The dropdown menu at the top right is the "Output Channel." If you check the "Monochrome" box, it sets the output channel to "Gray." The main area of the window is dedicated to a basic set of sliders. The values range from +200% to -200% for each channel. There is also the "Constant" slider, which enables us to tweak the final color mix.

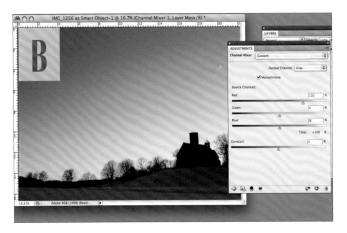

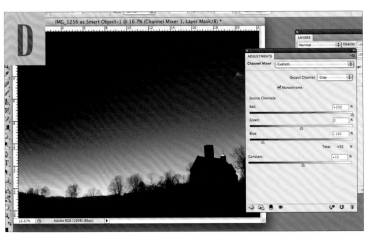

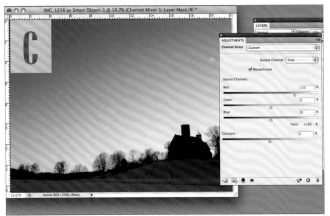

Here is a basic way use Channel Mixer. First, as with the Black & White adjustment we discussed earlier, choose the colors to make brighter and those to make darker (image B). For this example, I start with my sunset shot and use 100% of the red channel and 0% of the other two. I can use any balance I want, but the rule of thumb is to try to keep everything adding up to a total of 100%. My typical settings for most conversions are red: 60%, green: 20%, and blue: 20%, because the result is very similar to my old film favorite, Tri-X in D76. In this case, I want the sky even darker, so I adjust the blue

to -100% and the red to +200%, again equaling 100% total (image C).

I've boosted the Constant to +12%, which gives me some very interesting separation between the reddish-blacks of the church and the trees on the skyline, and the blue-blacks of the snow (image D). It is sometimes a bit unpredictable—especially within the framework of the precise Channel Mixer controls—but really all it does is to make the image darker and lighter. You're mapping the colors to gray, and then using the Constant control to just make the whole thing darker or lighter.

There's a perception out there that Channel Mixer does something different, something more powerful than, say, the Black & White adjustment. One theory is that the Channel Mixer control creates a more dramatic effect because it is a bigger tool—a bigger hammer, if you will—than some other methods of

adjustment. But the truth is, it is doing exactly the same thing that the Black & White adjustment does. The Channel Mixer decides the amount of luminance that each channel (R, G, or B) uses to create the final grayscale image. It can be used in the "Film/Filter" method previously mentioned by making a color adjustment layer (the filter) to feed to the Channel Mixer layer (the film). In the final analysis, however, we're just doing the same thing—deciding how to map specific colors to gray. (See Chapter 6 for more on Channel Mixer grayscale conversions.)

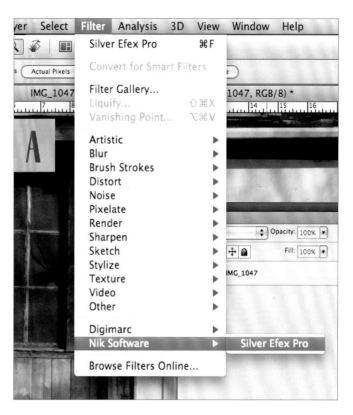

Plug-Ins

There are a few companies that offer some very nice grayscale conversion software; two notable programs work as a Filter in Photoshop. Just to give you an idea, here is an example of Nik Software's Silver Efex Pro and the popular Alien Skin's Exposure2.

Access the plug-in by going to Filter>Nik Software in Photoshop (image A). Select Silver Efex Pro; the control panel is shown here (image B).

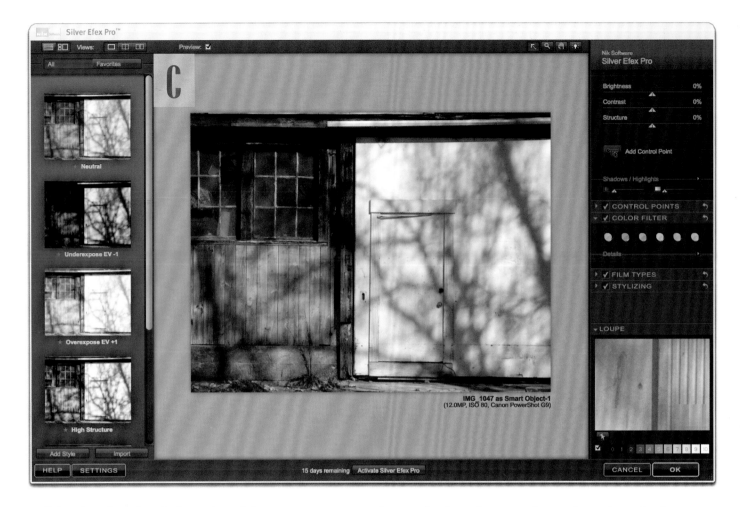

Selecting the plug-in launches this screen (image C). This puts you directly into black and white processing, and gives you all the tools, from a Channel Mixer/Black & White control to presets designed to mimic specific legacy film emulsions. I'll go into detail on a few plug-ins further on, but there's one important point to understand: Plug-ins, for the most part, are software devices that use the tools and methods of the host program, in this case Photoshop. They don't bring anything new to the process; they simply re-configure the tools in Photoshop to make them more usable for the task at hand. You are still making the same essential choice: how you want to render shades of RGB color to values of gray.

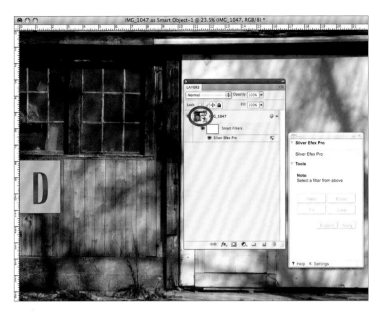

One of the benefits of a few of the Filter plug-ins is that they are supported by Smart Objects, as Smart Filters. When you apply them, they create not just a filter, but a Smart Filter that you can go back and re-adjust later. The icon circled in red is the Smart Object—we'll go through the details of Smart Object processing on page 96—and the Silver Efex Pro Smart Filter is shown above (**image D**). Chapter 8 covers grayscale conversions with a Photoshop plug-in more thoroughly.

The only grayscale conversion method left is the truly different one: Grayscale conversion in RAW processing.

Camera RAW Conversion

Converting color images to black and white at the RAW processing level is an entirely different ballgame. With a normal RGB image file, like JPEG, an individual pixel consists of three channels, one for each color. In a RAW file, a pixel contains only one channel and one color. The RAW processor—whether Adobe Camera RAW, Lightroom, or some other software—takes these individual pixels with one channel each, and builds them into pixels with three channels (known as "demosaicing" the RAW file).

In the process of mapping an RGB color file to grayscale, the starting point is almost always a file where every pixel has full, final color information. We can selectively move the individual colors to the desired value of gray. A RAW file, on the other hand, starts with just three colors

and their values. Mapping the colors to grayscale means you must first determine how those three colors combine to create a final color value for each individual pixel. Essentially, you decide how much of each R, G, or B channel is used, turn the volume up or down on a pixel, and use that value to build your final RGB pixels.

This has some interesting implications. If you're trying to create a dramatic black out of a blue sky on a regular image file, for example, you might make a move similar to Channel Mixer in an adjustment layer and turn the blue channel down and the red channel up. Eliminating the blue channel removes a third of your RAW image information—one out of the three channels. That data is no longer available to make important editing decisions in the process. The end result, when taken to extremes,

is a huge jump in noise or "grain," posterization, and banding issues. But RAW file processing gives you the ability to build data into the shape you want without throwing any information away. You can always go back to the "digital latent image"—the unprocessed information that represents the light that came through the lens—without any interpretation or pre-processing.

This example shows the HSL/Grayscale control in Adobe Camera RAW. If you start by simply clicking the "Convert to Grayscale" box, this is what you'll see (image A). The default settings are all channels set to zero; you're seeing the three basic channels—reds, greens, and blues—with some intermediate colors there, too (oranges, yellows, aquas, purples, and magentas). You can click Auto and it will

give you something like this: image B. Presumably, Auto is set up to give you a "human eye" response.

Here, image C, I've turned up the reds channels, turned down the blues, and feathered the transitions between them with the intermediate channels aiming for a nice smooth "curve" in an effort to reduce effects like banding and posterization.

Here is the color shot I started with (image D), and here is my adjustment (image E).

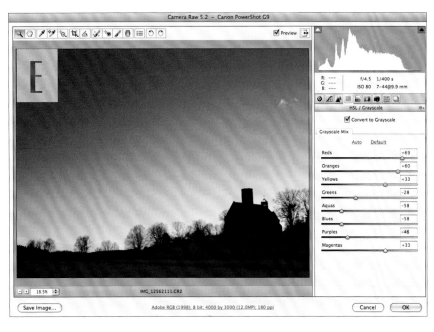

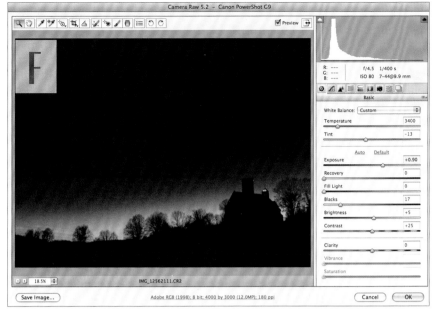

Exposure, Blacks, and Brightness. I made simple HSL/Grayscale decisions and fed that result into my Basic Tab adjustments, giving me a much more dramatic result.

In theory, this is very similar to the "Film/Filter" conversion method. The Basic Tab color adjustments are the film—the starting point in giving you color and image information. The HSL/Grayscale Tab is the filter—where you decide how you're taking that color information and mapping it to gray. (See Chapter 7 for more on Camera RAW.)

In this example, I started with the basic conversion and went to my main image controls (image F). I've pushed the Color Temperature to the far side of the blue range, messed with the

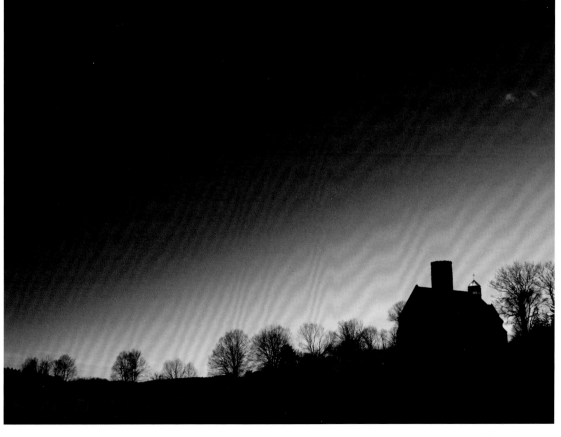

CHAPTER 3:

OPTICAL FILTERS & GRAYSCALE CONVERSION

The key to understanding optical filters is this: The filter color determines the color wavelengths that are allowed through the lens and thus recorded by the sensor (or film). Red filters allow red light through, lightening red objects and darkening blues and greens. Green filters allow green light through, lightening green tones and darkening reds.

Filters are used in traditional black-and-white film photography to control contrast and to correct for the disparity between the tonal response of Panchromatic film and how the eye perceives these tonal values. For example, blue and purple tones are normally perceived as darker to the eye than green, but Panchromatic film's heightened blue sensitivity causes blue to be rendered as a much lighter gray tone than green. Adding a filter to the front of a lens alters the way colors are rendered as gray tones. In black-and-white photography, a filter lightens the grayscale value of its own color (because it allows that color of light to pass through to

the film or sensor) and darkens other values, especially colors opposite it on the color wheel (because it blocks or filters these colors). Thus, a yellow filter will lighten the grayscale rendering of a banana, but darken the grayscale value of blue sky, making it appear more "natural" than if photographed without the filter. Filters are also commonly used in black-and-white portrait photography to alter the way Caucasian flesh tones are rendered as gray tones. A green filter makes flesh tones appear tan or ruddy and

exaggerates freckles, an orange filter will lighten them somewhat, and a red filter will dramatically lighten flesh tones and blemishes.

Optical filters are also used to fine-tune color to correct for nasty shifts in lighting, most often florescent lights. A color correction filter pack on the lens limits the colors the film has to work with, and the result is a more neutral tone. If you want to block one color (a greenish fluorescent, for example), you would filter the lens with the opposite color (magenta).

Optical Filters vs. Digital Grayscale Conversion

Now with digital photography and the RAW file, there is an array of powerful options for correcting color shifts using digital controls. We can shoot a full-color shot and use a preset white balance to correct color. We can use a neutral eyedropper to click on a gray patch and tighten up colors in post-processing. We can even do a test shot on a gray card and set that value as a custom white balance. Immediately, everyone threw out their color temperature meters and their huge packs of gel filters in favor of these "digital filters." Why bother filtering the lens when you can do it with digital processing?

It seems that digital processing could mimic the exact effect of optical filters, but this is not completely true. There are three general misconceptions about using optical filters on digital cameras. The first is that optical filters affect image resolution because the filter is blocking potential color information. The second misconception is that optical filters compromise sharpness and noise since they effectively eliminate two of the three channels of RGB data from the image file. And the third and most important reason why photographers dropped optical filters is that many assumed they could mimic the results in Camera RAW by cranking up the corresponding color channel for a desired filter effect—such as turning up the red channel to mimic a red optical filter. The thing is, that's not always true.

Optical filters with black-and-white photography are meant to limit the color palette. The fact is you get some interesting and high-quality images when you use certain optical filters on a digital camera's lens (such as red filters). This isn't simple, and it might not be the best way for everyone to shoot, but the effects are intriguing enough to set me off on a path of some serious shooting using this method.

Here is a brief overview of optical filter effects with black-and-white images. You can use this as a guide for adjusting the color channels in Camera RAW, or you can use the optical filter to limit your palette starting with the capture.

Red: The Red filter creates dramatic contrast: blue become very dark, green is darkened slightly. In landscapes, white clouds in a blue sky are emphasized dramatically. In portraits, Caucasian skin tones appear porcelain white.

Orange: The Orange filter is an intermediate step between Red and Yellow, with less dramatic results than the Red filter.

Yellow: The Yellow filter has a similar effect as Red and Orange, but far less pronounced. It darkens blue and brings out clouds. For portraits, Yellow reduces blemishes, freckles, and red spots on skin but doesn't remove them.

Green: The Green filter darkens blue and red, and lightens greens. It darkens blue skies in almost the same way as the Yellow filter but gives better separation between delicate hues of grass and foliage.

This first example is to test the idea that Camera RAW grayscale conversion can mimic the look of an optical filter for black-and-white photography. For reference, here is my standard RGB shot in full color (image A). I make a grayscale conversion in Camera RAW, mimicking

Optical Filters + Digital Grayscale Conversion

Now we know what an optical filter does: it transmits its own color. A red filter transmits red light—it allows red light to pass through and hit the sensor, and you're left with a file made up of a range of red colors. The range goes from dark red or red-black, to light red or reddish yellow.

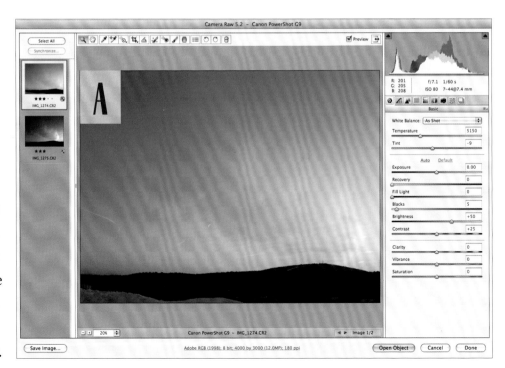

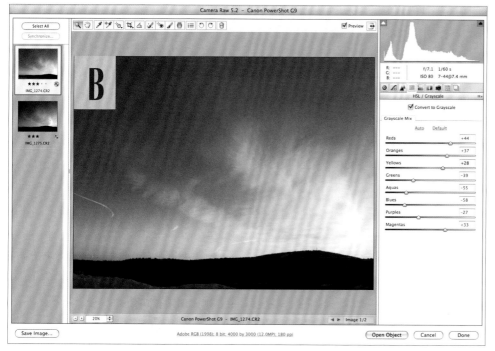

the "red filter" treatment by raising the red slider, dropping the blue slider, and feathering the ones in between (image B).

This shot I made with the red optical filter (image C). You can see that the image is a range of tones from deep red, to orange, to almost yellow. Those tones are all I have to work with. I can adjust the other colors in the HSL/Grayscale tab until the cows come home, but there's no change because those colors don't exist in the image.

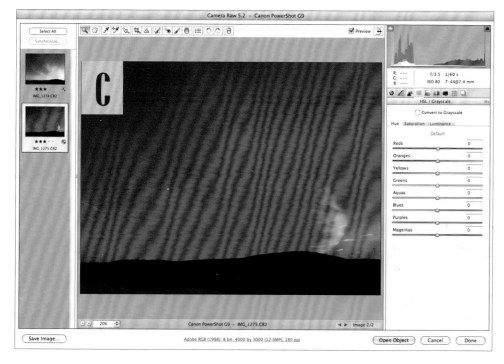

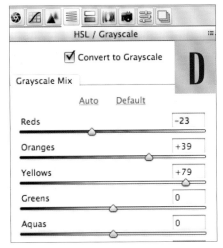

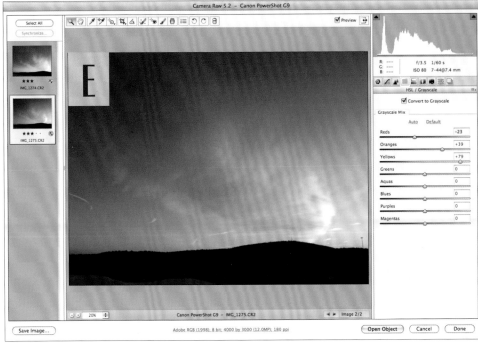

I select "Convert to Grayscale" and then adjust the luminance of those three red-based values (image D). Depending on the colors in the image, the result can be subtle (image E), or very dramatic, but it is definitely a different mapping of the gray tones. In this example, digital grayscale conversion does not reproduce the exact effects of an optical filter.

Now to the issue of noise gain and resolution loss: Here is my test board, shot in full color with my Canon G9 (image A). I convert to grayscale in Camera RAW and look at a detail of the photo (image B). I'm right down to the pixels here, and I can see the jagged squares and read the type pretty clearly.

I take the same shot using a red optical filter (image C). I zoom in on the same section of the image, and see essentially the same thing (image D). Look at the smoothness of the tones—there is not a significant difference there; maybe just a slight graininess to the gray areas at the very most. This example shows that the negative effects of optical filters can be negligible on digital image resolution.

This is a lesson I learn over and over in this process and I try not to come to a final conclusion based solely on what sounds logical and likely. Run a few simple tests; if they raise more questions than they answer, run a few more. Aside from discovering the truth of the question, you're probably going to find the answer to the more important issue: the best process for you.

There are benefits to both methods. Shooting full color images and using your Photoshop tools to control processing is certainly the most versatile process with the most latitude and the widest array of options from any point in the process. I'm capturing everything the sensor can get, and I have it available every step of the way. Optical filters on the lens set limits from the start, allowing for more creative control. Imposing these limitations on yourself and your tools invokes the "Paradox of Palette" from the point of capture rather than further on in the process. You're making a decision to limit your options at the start. But when you think in terms of what black-and-white photography is all about, it is a little different conclusion. Committing to this path at the outset enables the medium by limiting the tools and the process to serve your creative vision. Just as I ask you to limit your tools in Photoshop to allow you to build a process, filtering the lens limits your capture tools, to allow you to build a vision. You are, to a degree, at the mercy of the medium. Why, it's almost like shooting film again, isn't it?

CHAPTER 4:

BURNING & DODGING

Working with black-and-white images invariably involves burning (darkening) and dodging (lightening). This seems simpler than color work, since with color you have to burn and dodge brightness values in addition to color values. The truth is, because you're working with a limited palette of gray values, the burning and dodging process is a crucial part of creating an image with impact and a rich tonal scale.

Ansel Adams was a master of the black-and-white image, and famous for recreating nature in the way he envisioned it. Much of that vision was actualized in his darkroom using burning and dodging techniques.

Adams believed in these darkroom techniques so strongly that he made his collection of negatives available to the Center for Creative Photography at the University of Arizona in Tucson, allowing students to work with the original negatives to help them understand and learn the process of printing a negative. In musical terms, Adams believed the print was the performance and the negative was simply the score. This was a chance for a student to perform from the master's score.

Much of what Adams achieved was due to his choice of photographic paper and process, but most of the impact of that print is from his use of selective lightening and darkening of areas: burning and dodging.

Burning and dodging is the second part of our process, after grayscale conversion. We've made the essential decisions about how each color will be rendered and what shade of gray each hue will be mapped to, but we now have to decide where to take if from there. In a color photograph, burning and dodging is often a little less critical; you can certainly improve a color image with selective brightening and darkening, and even very selective color adjustment,

but a black-and-white photograph can live or die by the these subtle tone adjustments. Think again to our palette. When you're dealing with a select box of crayons, the use of every crayon becomes important.

I use layers, masking, and the Brush tool to burn and dodge an image for many reasons. Above all, they resemble the tools I used in the traditional darkroom in how they look and work, and how they fit into my overall workflow. As you'll see, everything I do is based around layers and masks, so if I can fit it naturally into that process, I will. (A detailed example of layers and masking is in the Appendix on page 218.) You may prefer a different method, but regardless of how it's done, burning and dodging makes a black-and-white print come alive.

Unless you consciously push yourself to see what burning and dodging looks like, you might be inclined to ignore it. Most of my students aren't very adventurous—they don't experiment much. I frequently hear how a student "doesn't work that way" or feels their photographs are good "when they come out of the camera." It doesn't take much to show them how a little darkening here and a little lightening there can make a good photograph into a remarkable photograph.

My advice: Experiment. This is not the traditional darkroom, where it could take hours to get a print. This is the beauty of the digital darkroom. Often, after a very short time and some powerful results, the burning and dodging process becomes an integral part of creating the photographer's vision.

Burning & Dodging Example: Layers and Masks

In case you haven't spent any time in the traditional darkroom, here is a typical burning/dodging workflow. As the enlarger projects an image on light-sensitive paper, we hold back light (generally using a lollipop-shaped paddle) to keep certain areas from going too dark (dodging). We give the paper another "hit," allowing light to shine on select areas (generally using a sheet of cardboard with a hole cut out) to give it more exposure, making it darker when processed (burning). In the digital darkroom we do this with layers and masks.

I lean heavily on the layers/masking workflow regardless of the conversion method. I apply edits and information in a layer and control which part of that layer gets applied to the image, which is called masking. I've gone into great detail on this subject in other books, and for your reference I've included a layers and masking workflow in the Appendix (see page 218). What follows here is how the layers and masking workflow can be applied to black and white.

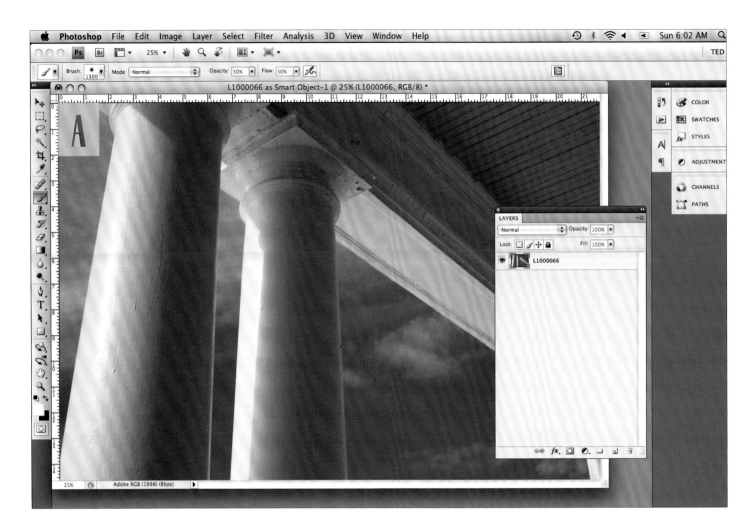

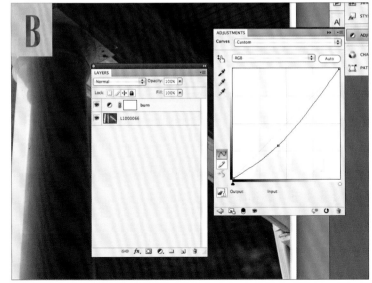

NOTE: Just a reminder on our setup: The Layers palette is open, the Color picker is set to white foreground/black background, the Opacity and Flow settings for the Brush tool are set to around 50%, and the Mode is Normal.

In the photograph above, (image A), I've added a "burn" layer that is essentially a Curves adjustment with the belly of the curve pulled down slightly (image B). An adjustment layer creates it's own mask automatically

(the white rectangle next to the adjustment layer icon—image C). When the mask is selected it is shown by an outline around the mask icon (image D).

The mask is transparent (white), and we're going to make it completely opaque; hit the keyboard shortcut Command/Apple+I (or "invert") to turn it black (image E). This will cover up our "burn" adjustment, and will look like we've gone back to our original image because the adjustment isn't visible. Next, though, we're going to paint on the mask with the Brush tool. Areas on the mask that we paint white will be completely transparent and will show the burn adjustment. Shades of gray that approach white will give us degrees of our burn. This is how masks give us nice, gradual tonal values—by giving us gradual degrees of transparency.

NOTE: Keep in mind that the mask is separate from the visible image—it is only controlling how much of that layer is applied. In this case, it's controlling how much of the "burn" adjustment we see.

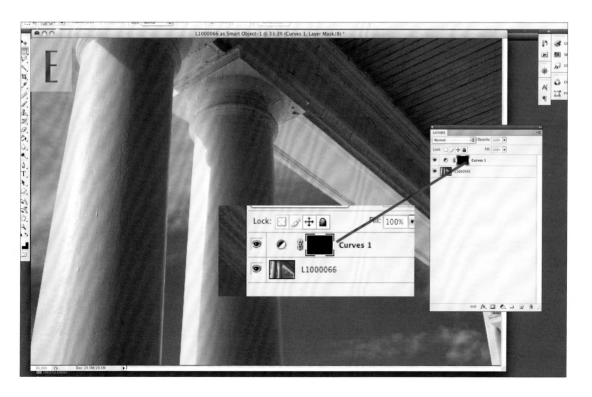

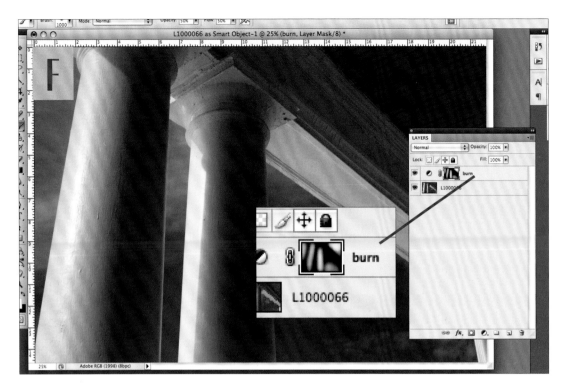

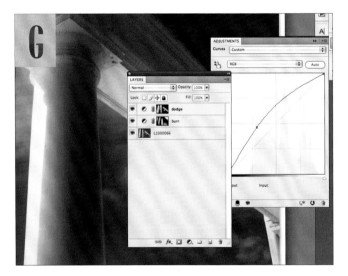

into the areas of the columns that seemed dark and muddy, and cleaning up some of the clouds and underside of the beam (image G).

NOTE: To manually create a mask, select the layer you want to build the mask on and click the Mask icon at the bottom of the Layers palette (image H). Smart Object layers do not automatically build masks, as we'll see in Chapter 7. From there, you're working with the same masking process: paint white on the mask for areas of the image you want to show and paint black for areas you want to hide.

Here's the mask with the burning moves (image F). Note the mask and where it is showing white areas: I've burned the right side of the columns, the ceiling in the upper right, and some of the sky. Now I make "dodge" moves on another Curve layer, holding back some of the midtones to give the image greater luminance

This is a very simple process and can be applied to virtually everything you want to accomplish in Photoshop. There are several ways to create the mask as well—some of which we'll go into a little later—but this is one of those skills that once it becomes a habit you'll wonder how you lived without it.

Refer to the Appendix if this is all new. If you're a little fuzzy, don't worry. We'll use this process in all of our examples so you'll see it repeated.

CHAPTER 5:

PREPARING THE WORKSPACE

Calibration

There are a few misconceptions about working in black and white, and at first it seems that some setup steps may not be necessary. Of these steps, the first and most commonly misjudged is display calibration.

Calibrating the display is only partly about color. Two of the most important steps in the calibration sequence are setting the black and white points to determine how the baselines values will be displayed.

This is absolutely critical in black-and-white work for pretty obvious reasons. We need to be able to read our tones of gray predictably through the entire range from black (RGB values of 0-0-0), to white (RGB 255-255-255). Things start to fall apart near the values approaching black—around (RGB) 20-20-20, where the separation between the values start to "chunk up" and fall off to pure black. When that happens, you lose detail and separation in the areas that have values of 15 to 20.

On the other end, displays often blow out white tones. A value of (RGB) 245-245-245 will display the same as pure white (RGB) 255-255-255. You can imagine this makes it pretty hard to edit detail in the highlights if you can't see the detail.

The color part of calibrating the display is also important. That deals with making the display appear neutral and helps map luminance from black to white so that the steps of gray are even.

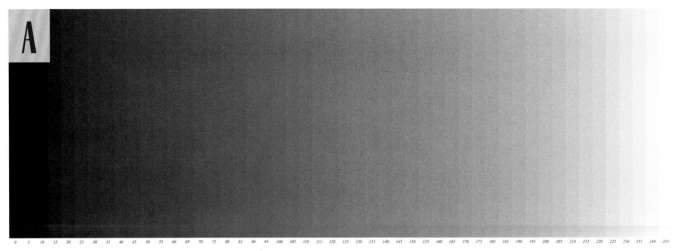

0 5 10 15 20 25 30 35 40 45 50 55 60 65 70 75 80 85 90 95 100 105 110 115 120 125 130 135 140 145 150 155 160 165 170 175 180 185 190 195 200 205 210 215 220 225 230 235 240 245 250 255

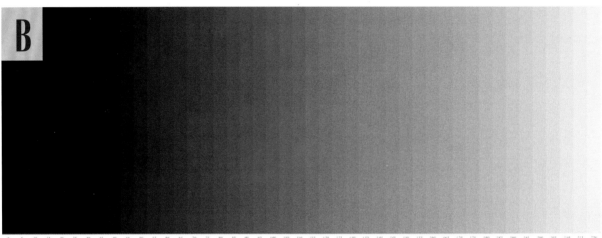

One of the tools I like to use is this grayscale step wedge (image A). If I open this in Photoshop, I can see how my display is behaving. Are the (RGB) 5-5-5 values clear and discernable from the (RGB) 10-10-10 values? Can I see the difference between (RGB) 250-250-250 and (RGB) 255-255-255? Is the ramp—the transition from dark to light—even and consistent?

Image A shows how this is supposed to look. Image B is what it looks like on a bad display, or a display that's not correctly calibrated. Note that the blacks and the whites are solid. This is a real mess. Not only do we have poor separation in the blacks and whites, but the midtones are blocked and stepped—that is, there are big blocks of tones that should be separated, and the tones are not making even, gradual transitions from dark to light. This display probably needs more than just a calibration. It may be either unable to display tones accurately, or it may just be so old that it's not serviceable any more.

This grayscale step wedge is something we're going to use a lot; save it somewhere handy. You can download it from www.teddillard.com or

have some fun and make your own. For monitor calibration guidelines using some common devices and systems, see "Calibrating the Display" in the Appendix section on page 210.

Color Settings in Photoshop

Setting the color management policies in Photoshop is something that may seem unnecessary, since we are working in black and white, but is essential. The fact is we work in a basic, fairly universal working color space—

AdobeRGB 1998—not in grayscale. To select the working color space, open Photoshop and go to Edit>Color Settings (image A). Select the "More Options" button (image B). Start by selecting "North America Prepress 2" from the pulldown menu (image C),

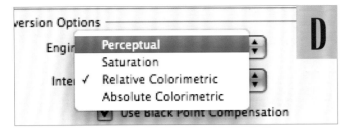

then in the Conversion Options select Perceptual (image D). Save and name the settings and you're done (image E).

This establishes a standardized set of working policies in Photoshop, and since we're working in an RGB environment even though we are converting to grayscale, it's important to be in a controlled, standard color management workspace.

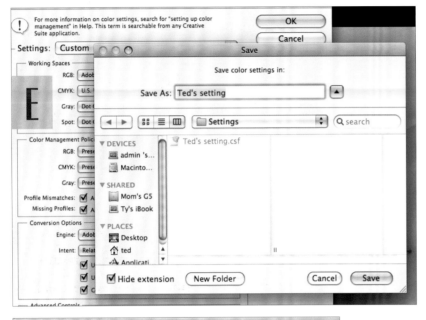

NOTE: If you're opening files edited before you made these color policy changes, you may get the "Profile Mismatch" warning (image F). In almost every case, simply select the "Convert to Working Space" option.

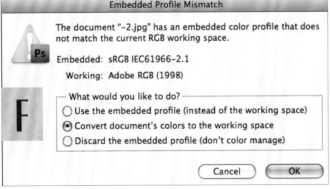

Reference Values

This shot of my wife, Teresa (image A). It is a great example of an image that can be hard to evaluate for a true tonal scale because of the tricks your eyes (and brain) play on you. Are the blacks really as black as they can be? Are the whites pure white? Are the gray skin tones really light gray, or are they darker than they seem?

The Desktop: The first place I'd suggest starting is setting the Desktop color to middle gray (image B). (Go to System Preferences>Desktop and Screen Saver>Desktop). Select Solid Gray Medium from the Solid Colors folder in the navigation window. This sets the Desktop to around (RGB) 150-150-150—not quite the very middle, but a useful reference. It also lets you check your display for neutrality and evenness. If it looks pink, or uneven, you'll see it right away.

Now, when I'm in Photoshop, I can see a nice, neutral gray in the background behind the image (refer to image A again). This gives me a feel for the overall brightness of the image before I ever start editing.

The issue is perception. Next to pure black, a very light gray may seem white. In an image full of dark grays and blacks, even a medium gray may appear white. Your eye automatically stretches or compresses the values in an image to fit its expectations. We see tones in the context of the image.

This dawned on me in the darkroom, and the solution I came up with was a reference strip to compare tones in my photograph to an actual sample of pure white, pure black, and grayscale tones in between. There are a few ways to do that in our digital darkroom, and one of the easiest is to simply set our desktops and backgrounds to white and black reference values.

The Image Window: Another reference point is the image window. In Photoshop>Preferences>Interface, look at the Screen Mode backgrounds. This controls the background color of the image window; you can see it if you pull the window corner out past the image border. I've set my Standard Screen Mode to black (**image C**), and here is the background color when I increase the image window (**image D**): a pure black border directly behind the photo, and a nice middle gray on the desktop.

Interestingly, this shows that the values in the lower right corner of my image are not pure black after all (**image E**). The tones appear to be dark gray with a bit of detail. This is obvious now because of the pure black point of reference.

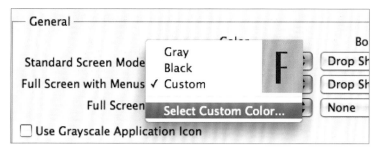

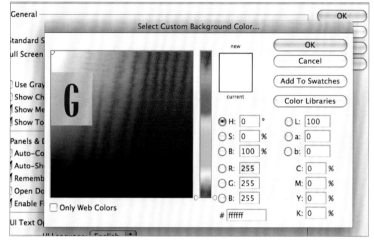

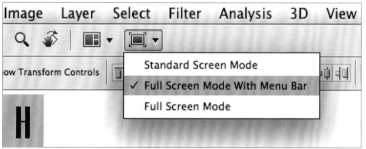

The Photoshop Workspace: I can also set another background reference to white, using the Full Screen with Menu viewing mode. Again, go to Photoshop>Preferences>Interface to get to the Full Screen with Menus selection (image F). Under Select Custom Color, pick White (image G). Now, when I go to my Screen Mode selection and select Full Screen Mode with Menu Bar, I get a solid white background (image H). This is going to help me find and evaluate the image highlights. What seemed pure white against a black background (her cheeks, for example), is clearly bright gray when compared to actual white (image I).

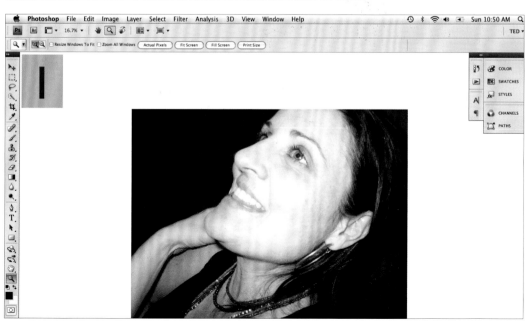

The Step Wedge: Here is a preview of another little technique that will let you be a little more exacting. I'm going to keep the image of Teresa open, and then go back to my step wedge. I open it, select a small strip, and copy it—Command+C (image J). I go to my shot of Teresa and paste it—Command+V (image K). This gives me a layer with a range of tones that I can move wherever I want. I can zoom in and take a good look at exactly what and where my tones are. Here, I'm measuring those highlights

on the cheek (image L). Now, I'm looking at the shadows (image M). I can also slide it around to see what values certain areas are on my grayscale by comparing the ramp to the image (image N).

I can also print the step wedge. If I compare the printed step wedge to an image print, I see how the printer reproduces each value. If you use it to evaluate where your grayscale values are and understand how the printer translates those values, you will have a better guide for adjusting. (We'll talk about this further in Chapter 11.)

The point is to set up your tools properly. In the digital darkroom, a few simple tools can give you some very powerful results.

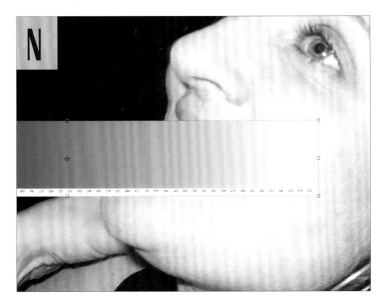

Smart Object Prep

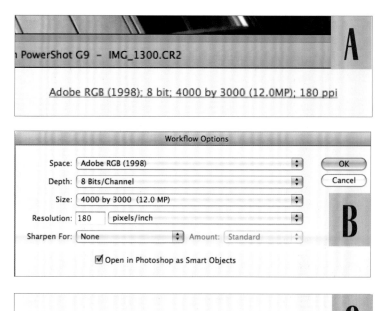

Here's a fascinating subject with a lot of depth. There's a lot to be said for working in the Smart Object workflow—so much so that I wrote an entire book dedicated to the subject (*Smart Object Pipeline*). If this seems like a new method you want to step into, here is the very briefest of introductions.

First, lets answer the obvious question: Why work with Smart Objects? The simple answer is that it allows you to directly access the un-processed RAW image file and re-process it for specific edits. Smart Objects sit as a layer. When you click the Smart Object icon, you gain direct access to the RAW file, and re-process as you see fit. You can also add a filter—a Smart Filter—and reset the filter controls. This is more than simply a "non-destructive" workflow—this is truly a constructive process. We can go back to the RAW file and rebuilt it with pure original information.

The entire power of layers and masks is accessible with a Smart Object workflow as well. Anything you can do with layers, you can do once the RAW file is "Smart" (and more). The following is just a brief overview of the basic steps, not the effects of the adjustments on an image. We'll go over the Smart Object workflow in more detail

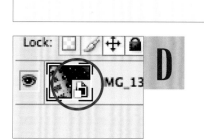

in Chapter 7, and you can reference Chapter 12 for a detailed workflow example.

First, in Camera RAW, go to the Workflow Options (image A). Click this link to get to the main Workflow Options window (image B). At the bottom of that window is the "Open in Photoshop as Smart Objects" box (image C). Click it. Feel any different? You are now working in a Smart Object workflow. When you hit the "Open Object" button in Camera RAW, you'll see a little icon in the Layers palette (image D). That tells you you're working with a Smart Object.

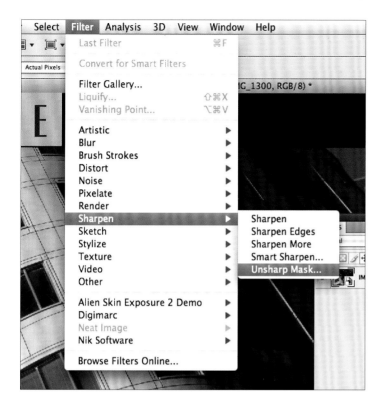

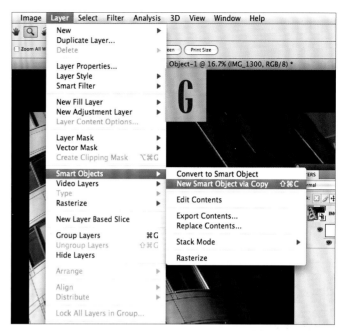

Let's see more. Go to a filter; I'll use Unsharp Mask for this example (image E). When I apply this filter, it creates an addition to the original Smart Object—a Smart Filter—as well as the filter's own little mask (image F). To add layers to make spot adjustments, I make a new Smart

Object. Go to Layers>Smart Objects>New Smart Object Via Copy (image G). This makes a new, discrete Smart Object; I can make my usual edits here—burns, dodges, and spot corrections—using a mask (image H).

This is a typical setup for the Smart Object RAW workflow (image I). Here I've made a "dodge" move to lighten the image, masked it, and then opened up the mask on the specific areas I want to lighten.

This should get you started. For the basics on masking, see page 218 and for more on this, we'll see how to use this in our examples. It gets pretty powerful, and sometimes complicated, but learning this method is worth it if you want the best image quality possible. (For the final word on Smart Objects, Camera RAW, and the constructive Photoshop workflow, find a copy of *Smart Object Pipeline* at a bookstore near you!)

NOTE: If you just drag the Smart Object layer down to the "copy Layer" icon, you'll make a copy, but a copy that is completely linked to the original layer. Beware that any changes you make on one will appear on the linked copy, too. Also note that we're making a new Smart Filter too—this move duplicates the whole thing.

BOOK 2:
GRAYSCALE CONVERSION WORKFLOWS

You have seen the pieces of the process and understand that the conversion methods are the biggest difference between black-and-white film and digital photography. Now we will see how they start to fit together into a process.

The first process we'll explore is Adjustment Layers with Channel Mixer for the grayscale conversion. This uses all the components of the Adobe "non-destructive editing" process, and the image information remains as background layer where you can apply corrections, make masks, and re-edit it as needed.

Then we'll look at Camera RAW grayscale conversions, using the source information to render the file to shades of gray with the digital "latent image"—the unprocessed RAW image data from the sensor. Then we'll add the Smart Object RAW process to create a fast, powerful workflow with almost limitless possibilities. This is the basis for what I like to call additive editing.

Finally we'll look alternate processes such as plug-ins and third-party grayscale conversion software like AlienSkin or Nik Silver Efex Pro to develop a defined set of tools tailored specifically for the black-and-white enthusiast.

CHAPTER 6:
CHANNEL MIXER & ADJUSTMENT LAYERS

I always suggest thinking about layers as a pyramid. Make the big foundation edits at the bottom—the edits that affect the entire image—and get progressively more refined as you move to the top. Channel Mixer is a big move—the main grayscale conversion—and should stay at the very base. Each step above it is slightly smaller and very organized. Decide which edits you use universally on your images and make those the foundations. Let's start with the Channel Mixer—a simple, "non-destructive" grayscale conversion process that gives a lot of control.

Here's the image and the open Layers palette (image A). Use the Adjustment Layer icon—the little half-black, half-white circle at the bottom of the palette—to get to this menu (image B). When you select Channel Mixer, Photoshop automatically builds a new adjustment layer

and opens the control panel for Channel Mixer. Check the "Monochrome" box and this is what you get (image C).

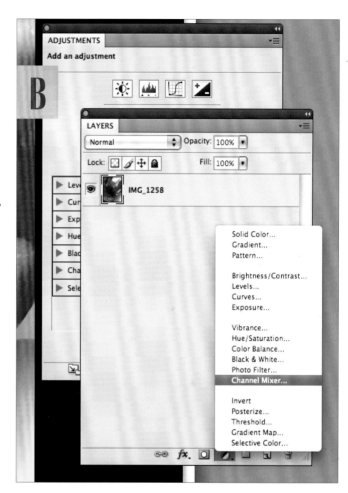

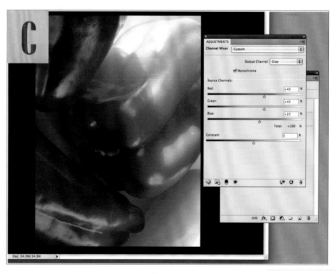

The starting point for the Monochrome setting is R–40%, G–40%, and B–20% (remember, the percentages should add up to 100%). Adjusting the channels is a simple matter of dragging the sliders up and down, to control the amount of each channel, and how it's used to build the luminance of the Gray channel. Think in terms of mapping color: Turning up the Red channel makes red things brighter, and this goes for each color channel. Turning down the color channel makes that color darker.

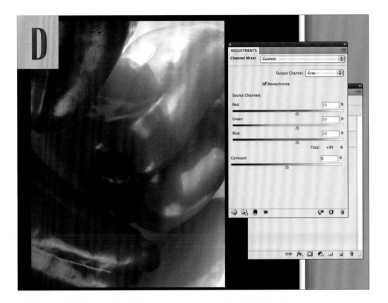

This is what the peppers look like with all three channels set equally at 33% (image D). I originally envisioned the red pepper being fairly bright and the green one dark. To achieve that, I slide the Red channel up to 80% and compensate for that by setting both the Green channel and the Blue channel at 10% (image E).

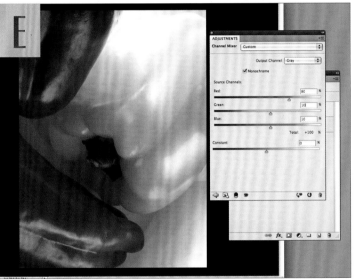

NOTE: The pull-down menu at the top of the Channel Mixer window offers some presets based on optical black-and-white filters (image F). This is a handy menu but not everyone utilizes it. Shooting a digital color image and using Channel Mixer to make the grayscale conversion is essentially the same thing as using an optical filter. Knowing this is good and gets you started with the Channel Mixer, but when you're looking at using a secondary color—say, a yellow filter—you might try one of these presets

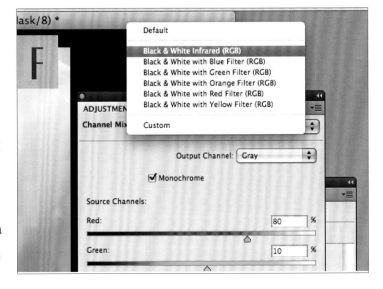

to get pointed in the right direction without the need for blind experimentation.

The Channel Mixer color settings in image G are the values that Adobe claims mirror the response of the human eye when it converts color to black and white. I don't know what that is based on, but I can tell you that is not how my eye sees. I see a lot more like R-60%, G-20%, B-20%, and that is what I'm going with (as shown in image E).

Having set the color channels in the Channel Mixer adjustment layer, let's refine the image. Here's the standard workflow for using Adjustment Layers, with the full-color image on the bottom (image H). Look closely: Channel Mixer is the "base" adjustment, the first Levels adjustment layer sets the black and white points, and

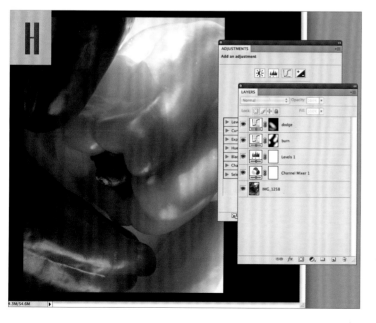

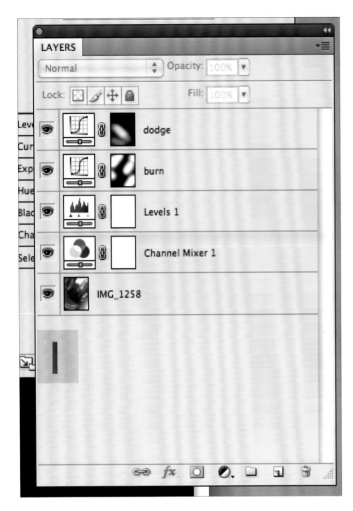

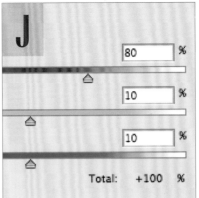

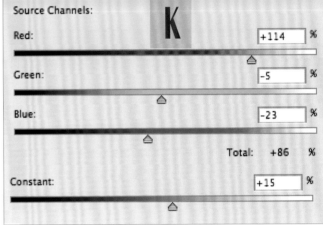

the typical "burn" and "dodge" layers have been applied (image I). (Don't forget to look at page 218 if you need a refresher on the Layers/Masking process.)

You can make the Levels, Curves, and local burn/dodge corrections first, and then apply Channel Mixer, but I prefer to do it this way. If you develop a habit—a process—then you're less likely to get confused by random steps in your process. Remember, big edits should be on the bottom of the Layer hierarchy and smaller on the top. (You can always move the layers around to order them,

but it is much easier to do the edits in sequence so you know how they affect the image.)

Note a couple of details: First, all three channels should add up to roughly 100% to maintain the overall brightness of the image. There is a running total given under the color sliders (image J). The "Constant" slider is a brightness control, but it isn't a very customized adjustment. If you want to make a Channel Mixer move that makes everything dark, just pump it up a little by sliding the "Constant" up a bit. (Image K) shows a rather uncommon combination of moves that requires a boost on the Constant slider to bring the values back up.

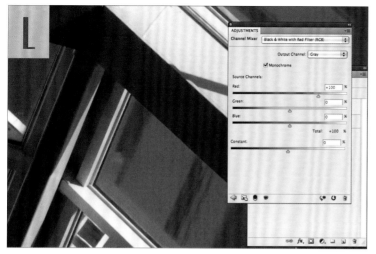

Since I mentioned uncommon combinations, here is a small caution: As you move away from the "normal" adjustments and towards an "effect," it is likely you will have areas with rough transitions, showing posterization—clumps of grainy tones—and other problems. Essentially you are asking more of a certain channel than it can give you. Here's a sample of a standard "red filter" adjustment (image L). Here's the same image with a severe treatment that some folks use to simulate an infrared effect (image M). Note the strange halo effects in the edges, and the grainy areas in some of the midtones. These issues are just something to keep in mind.

Channel Mixer Variations: Film/Filter

There's a relatively old method of black-and-white conversion known as the "Film/Filter" method. In the digital darkroom, the "film" layer is a grayscale conversion, and the "filter" layer is a color tone adjustment. It works like this: Open your image and make a Channel Mixer layer to convert it to grayscale (image A). This is the "film" layer—just like using black-and-white film in your camera. Under that layer, add a color adjustment layer to fine-tune the color balance of the image. This is the "filter" layer—it filters the full color image through a color adjustment. That color adjustment affects the tones hitting the "film" layer and thus affects the grayscale conversion—just like an optical filter tones the light that hits black-and-white film.

For this example, I go back to the Layers palette and add a Curves adjustment layer —this is the "filter" adjustment (image B). (I like to use Curves to adjust my color balance, but you can use whatever you want.

The most common color balance adjustment is Hue/Saturation.) I select the red channel, make any adjustments needed (image C), and then move to the blue channel to make adjustments (image D).

I'm creating the Curve "filter" layer—adjusting the red and blue channels—under my Channel Mixer "film" layer (image E). I'm making the basic conversion with the Channel Mixer, but I'm controlling exactly what that conversion effects by placing the filter layer under it, which in

effect chooses the information that is "fed" to the grayscale conversion. For reference, here is the base image (image F). Here is the grayscale version with my "film layer" adjustments (image G). This is the "filter layer" adjustment shown without the Channel Mixer adjustment visible (image H). We are simply controlling the tones that the Channel Mixer will process.

Channel Mixer Variations: Film/Filter + Smart Objects

If you like to work with Channel Mixer and like to work in Adobe Camera RAW for basic edits, you can combine the two workflows using Smart Objects. (The next chapter details the Smart Object workflow, and a Smart Object primer is in the Appendix on page 224.) To begin, open up the Workflow Options in Adobe Camera RAW and check the "Open in Photoshop as Smart Objects" box (image A).

This is what the Layers palette looks like in Photoshop when you are working with Smart

Objects and Channel Mixer (image B). My base image layer has that funny Smart Object icon. If I double-click that icon, it brings me back to the original file in Camera RAW and gives me access to all the color and contrast controls there.

I go back, make some adjustments to the RAW image, and feed those changes to Channel Mixer in Photoshop for grayscale conversion. Here's my black-and-white image (image C). Here's my image with the Channel Mixer layer turned off (image D).

Instead of using an adjustment layer under the conversion—the Film/Filter method—I'm using Camera RAW. The Smart Object simply allows me to get to Camera RAW easily and quickly.

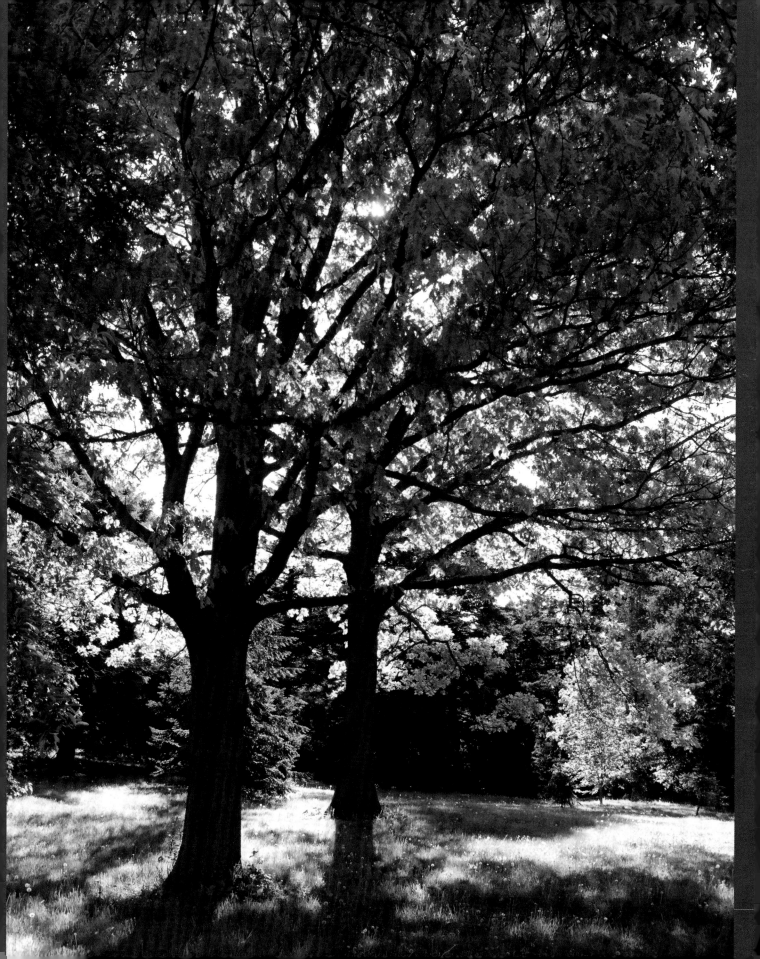

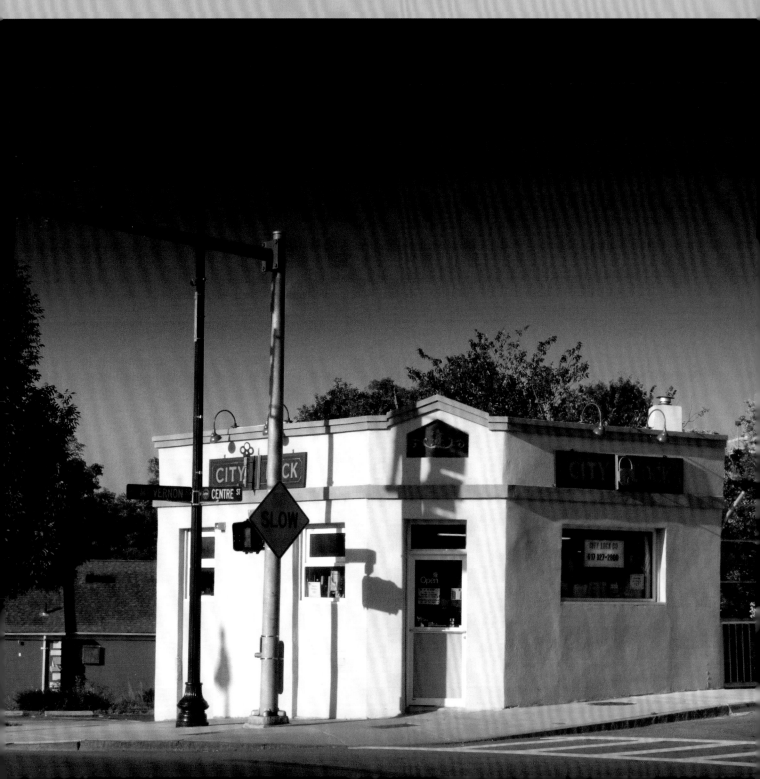

CHAPTER 7:

CAMERA RAW & SMART OBJECT WORKFLOWS

The Basic Camera RAW Workflow

The HSL/Grayscale controls in Camera RAW are very similar to Photoshop's Black & White adjustment tool we addressed in the first part of this book. They are both designed to make individual color mapping decisions very easy. Here's a brief look at how that works.

First, we start with a color image in Camera RAW (image A). I want to separate this little cornerstone building from its environment. It is an interesting, anomalous shape within the context of newer brick and steel structures in the background. I envision the image as black and white with the building as the main emphasis of my photograph; now I need to use the right tools to achieve that vision. My strategy is to darken the surrounding environment, allowing the little building to be the brightest subject in the frame.

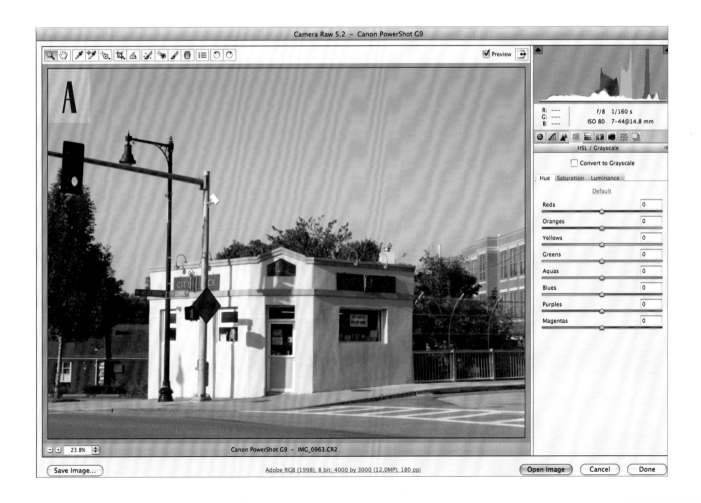

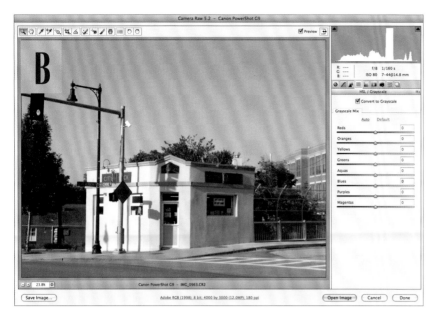

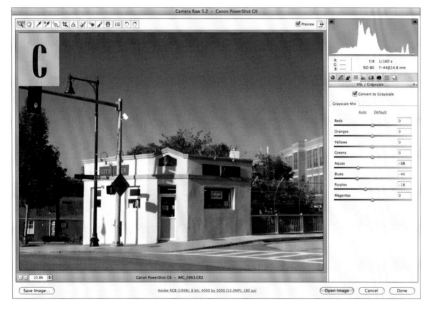

This is the default grayscale conversion in the HSL/Grayscale tab (**image B**). My first step is to concentrate on the sky, since it is a large, even area that needs editing. (Remember the pyramid strategy and start with the largest edits first.) I pull down the blue channels to darken the sky. I must be careful here, because if I go overboard I'll get image noise (**image C**). I've pulled the aqua and blue sliders down, and a bit of the magenta slider as well.

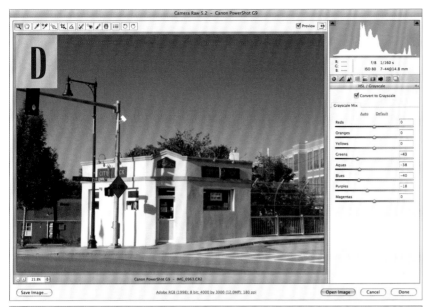

Next, I darken the foliage by pulling the green slider down (image D). I'm starting to get the effect I envisioned, aside from the brick buildings in the background. They are a fairly high grayscale value, so I pull down the orange slider too (image E). This brings the orange down significantly. I adjust the yellow and red sliders down to "feather" the adjustment.

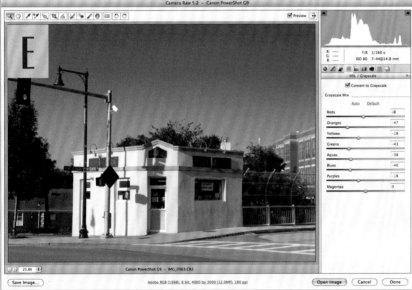

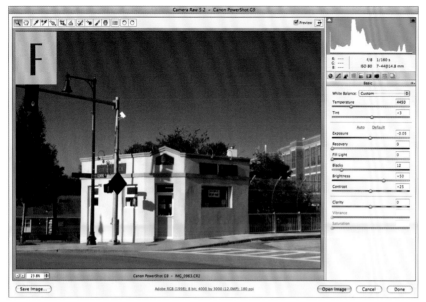

This next step is the Camera RAW equivalent of the Film/Filter method (detailed on page 84). The grayscale "film" adjustment is made in the HSL/Grayscale tab, and the "filter" adjustment is made in the Basic tab. Go to the White Balance section under the Basic tab and slide the Temperature to the blue side of the scale. This pumps blue into the image, and as that information feeds into the HSL/Grayscale adjustments I've made, those blue tones are mapped down accordingly. The result is an increased darkening of the sky without noise or grain problems (image F).

Now I'd like to bring the sky down even more— I envision the top of the sky at almost pure black. Using the Gradient tool (image G), I click and hold at the top of the sky, and drag it out to the roof of the building (image H).

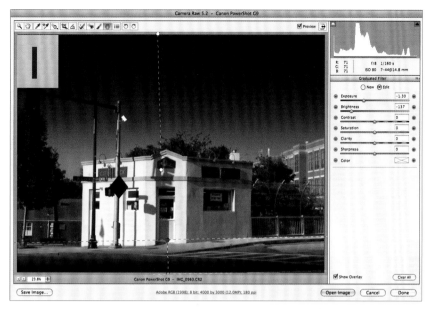

This is like burning and dodging, but creates an even graduation from the dark to light tones. I set this adjustment to pull the Exposure and Brightness down; I like it so much I'm going to do the same thing to the street on the bottom of the frame (image I).

Now I'm ready to look at it in Photoshop as a Smart Object. Open the Workflow Options link, check the "Open in Photoshop as Smart Objects" box (image J), then select "Open Object."

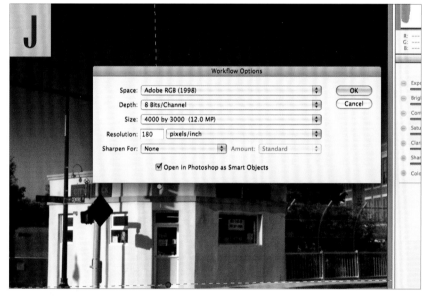

The Basic Smart Object Workflow

NOTE: As I mentioned before, all of my processing is done using Smart Objects, especially when I work with RAW files, but also when I edit TIFFs and JPEGs. Go to Photoshop>Preferences>Camera RAW (image A) and set it to open JPEGs and TIFFs (image B). Then follow along with the workflows.

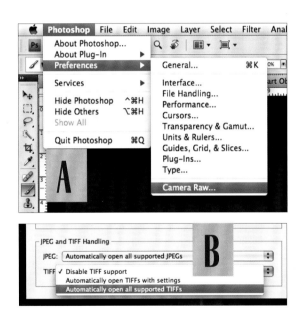

There are a few reasons I use the Smart Object workflow. It is an incredibly powerful process. It uses the RAW file for all your image information and rebuilds the "digital latent image" to suit specific needs. But the biggest reason is that the process of layering adjusted RAW files on top of one another in Photoshop builds the image information. That makes this process a truly "constructive" editing workflow. It literally adds image information to your working file.

The Smart Object workflow allows for astounding image quality. It fills in the gaps, builds richness and texture, smoothes gradations in tones, and improves actual resolution. This editing method builds the file size—meaning you have to store large image files—but that is a price I'm willing to pay, especially considering the affordability of data storage.

The best part: It is a simple process. I can accomplish virtually everything I want to do using some very basic tools: Layers, Masks, Adobe Camera RAW, and the Brush tool. A few good tools, a simplified process, and established workflow habits all contribute to a fast, efficient, and predictable image-processing method. For an in-depth course on the Smart Object process, check out my book, *Smart Object Pipeline*.

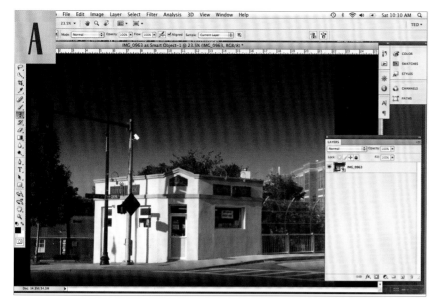

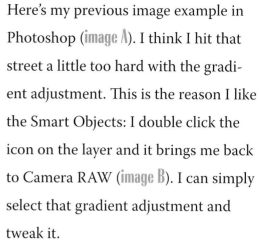

Here's my previous image example in Photoshop (image A). I think I hit that street a little too hard with the gradient adjustment. This is the reason I like the Smart Objects: I double click the icon on the layer and it brings me back to Camera RAW (image B). I can simply select that gradient adjustment and tweak it.

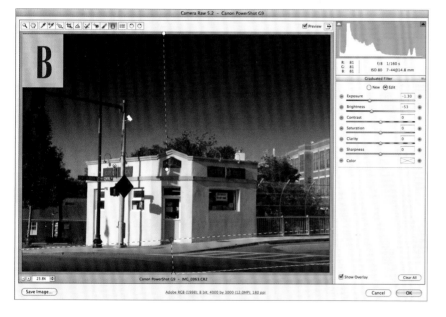

To bring the image in line with my vision, I change the gradient angle a bit and feather it back, making the Brightness higher (image C). With the background set to black, I can evaluate the sky and see that it is a deep black.

I've got one other issue: The white streetlight on the pole. I find it really distracting; it pulls my eye away from the subject. I could either darken

it or make it go away altogether. I like the latter option, so I double-click the Smart Object icon and go back to Camera RAW. I zoom in (image D), select the Spot Removal tool (image E), and hit it a few times with the Clone option selected (image F). This is the result (image G), and I uncheck Show Overlay to see

the image without the distracting lines (image H & I). Here's my final image (image J).

All that's left to do is to size the image, apply Unsharp Mask, and make a work print or two. Any tweaking I want to do after that happens simply by double-clicking the Smart Object icon to get back to the RAW file. It is important to save your working file—in Photoshop, that is a PSD or TIFF file—to retain the flexibility offered with Smart Objects and Layers, and then convert the image to your final file output.

Smart Object: Black-and-White Workflow

In this section we'll cover the basic Smart Object processing of a black-and-white RAW image. Once we see this, we can take it to the next level and get a feel for the power within this process.

Here is my color image (image A). I'd like this image to show a dramatic contrast, so I note that the blue-toned water needs to darken, and the yellowish white of the boat hull should retain its luminance. My first move is to go to the

HSL/Grayscale tab and select my black-and-white custom preset, (image B). I created this grayscale conversion profile to favor the red channels and bring down the blue channels. After the image has been converted to grayscale, then I use the Spot Removal tool to take the unwanted spots out of the water (image C). I select "Open Object" and I'm in Photoshop (image D).

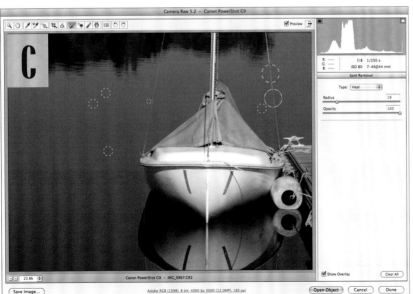

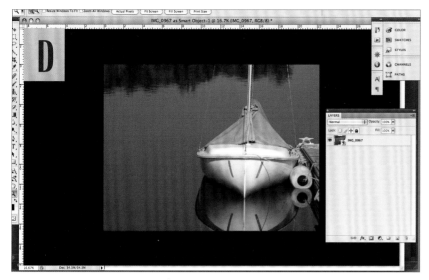

NOTE: Spotting and Unsharp Mask are usually two things that you want to do last because they tend to be applied to specific image areas, but in this case I am building them into my initial layer. I want to apply spot retouching and Unsharp Mask first because I know ahead of time I will be making copies of this layer; if the spotting and sharpening edits aren't in the first layer, I'll have to add them to each one later. The more you work with this method, the easier it is to judge when and where to make these edits.

Now I want to apply my Unsharp Mask settings. I go to Filter>Sharpen>Unsharp Mask (image E). This builds a Smart Filter automatically because I'm adding it to an existing Smart Object layer (image F).

NOTE: Smart Filters are one of the secrets of Smart Objects. A Smart Filter is a regular filter applied to a Smart Object layer; when you apply a filter to a Smart Object layer, it is automatically converted into a Smart Filter. With a Smart Filter, I can go back and change the settings of the filter later just by double-clicking the filter layer. We'll see more of that in a bit.

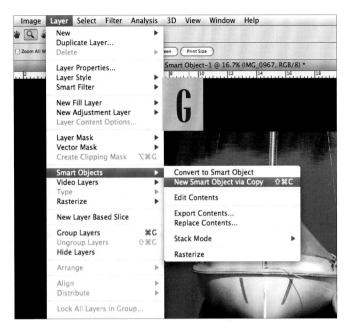

Now I want to burn the background water, and I want the tree line that is reflected at the top of the frame to approach pure black. My first step is to make another Smart Object layer: Layer>Smart Object>New Smart Object via Copy (image G). (I've created a custom keyboard shortcut for this move because I do it constantly. See how to do that on page 228.) Now there is a new layer with all of the edits from the original layer (image H).

I double-click that new layer and it takes me back to Camera RAW. To bring down the values in the water, I pull the color over to blue and I pull the Exposure and the Brightness down a bit too (image I). Select "Open Object"

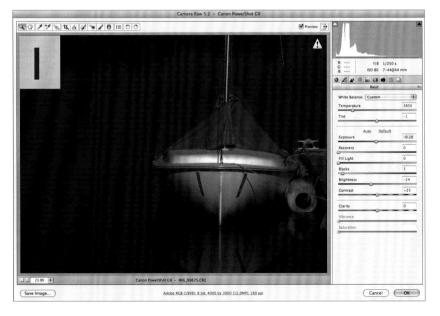

and get ready to start masking. I make a mask and use the Brush tool to paint white on the black mask to lighten the boat and its reflection (image J).

Now I want to darken the tree line. I make a new layer and rename it immediately to keep my edits organized (image K). Then I pull the greens and blues down on this new layer (image L).

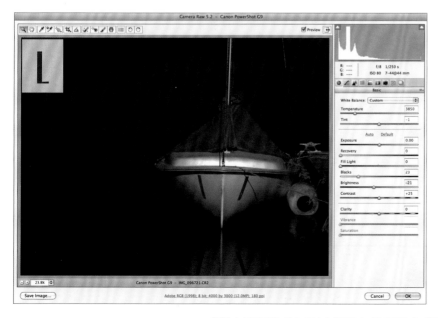

I mask the layer and target the trees (image M). With a black background, I can see that my trees are almost pure black, which is right where I want them. However, I am having trouble getting a read on the brightness of the boat's hull. I want it to be a nice, clean white—it needs to glow—and because there is so much black, I'm worrying that it looks as white as it does because of context and not its actual value. To get a more accurate reading, I open the grayscale step wedge (image N). You can download the grayscale step wedge from www.teddillard.com.

Open the step wedge, select a piece of the strip (image O), and copy it ; Command+C (image P). Close the file, go to the boat image, and paste the selection ; Command+V (image Q). Here's what I have (image R). Using the Move tool, I can slide this anywhere to compare the actual values with those in the image.

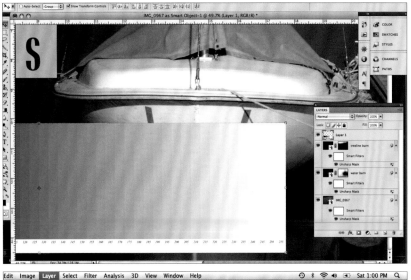

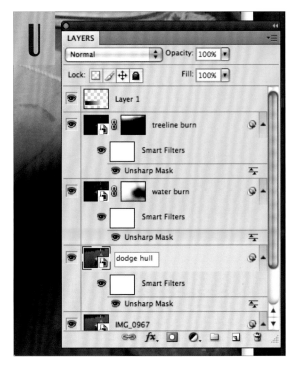

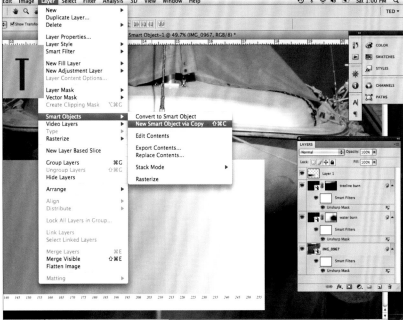

I've moved the step wedge next to my hull, zoomed in, and can see that I could use a bit more brightness there (image S).

I add another layer at the bottom of the palette to brighten the boat. Select the first layer, create a "New Smart Object via Copy" (image T), name it immediately (image U), open it in Camera RAW, and lighten the hull (image V).

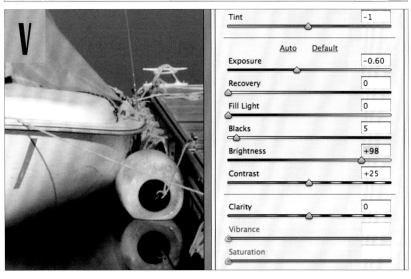

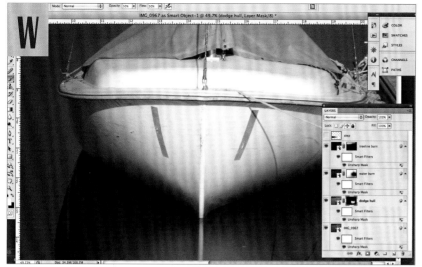

I turn my step wedge layer off and take a look (image W). Turn it back on and compare the tones (image X). I'm happy with this result (image Y).

This may seem like a really different way of working. Smart Objects and Smart Filters are relatively new developments, and it's not how most photographers learned post processing. Take it one step at a time, use the Appendices to build the basic skills, and start experimenting.

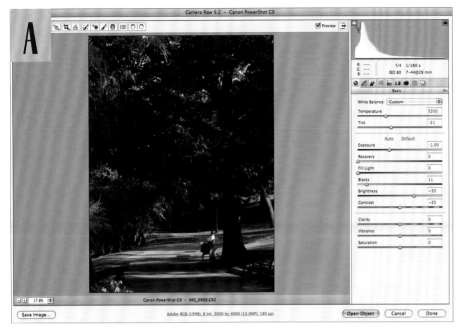

Smart Object: Multiple Conversions Workflow

This section shows an example that illustrates how Smart Objects are used to re-convert a file and combine the renderings selectively.

We start with this nice scene from a park (**image A**). I convert it to grayscale, brightening the reds and turning down the greens to get what I'm looking for: A dark feeling with emphasis on the shaft of light (**image B**). I open the Smart Object (**image C**) and make the Unsharp Mask filter move (**image D**). Now I'm ready to evaluate my image.

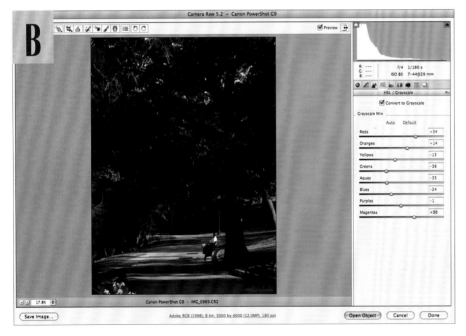

This rendering creates deep blacks from the green tones, but I want some areas of luminance. Just making the dark areas lighter does not add any detail or separation, because the greens were already rendered in a way that discards that information. The green leaves range from dark blue-green in the shadows to yellow in the highlights. The first conversion pumped all that variation down to simple dark gray tones.

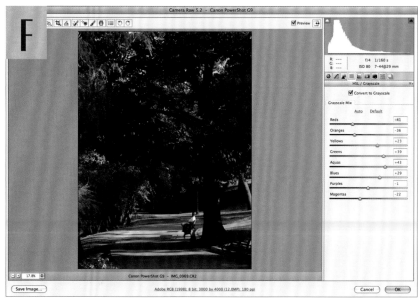

Here is a solution: Add another gray-scale conversion. Go to Layer>Smart Object>New Smart Object via Copy, and open a new layer (image E). When I click that layer's Smart Object icon to return to Camera RAW, I boost the greens and turn the reds down (image F). I bring this new grayscale conversion into Photoshop as a layer and mask it, selecting some of the open areas of the trees to give my blacks some visual depth. Instead of being a flat mass of black, it's now an area that has variation and depth (image G).

Take a look at these comparisons. This is the first example, zoomed in on the leaves (image H), and this is the second example (image I). We've done more than just lighten the existing tones—we've brought detail and separation to the leaves themselves.

Once you are comfortable with this process, add a third conversion elsewhere in your image. This is like reprocessing your negative in the darkroom over and over to get exactly what you want from the image. Although that is impossible in a traditional darkroom, Smart Objects make it possible in the digital darkroom.

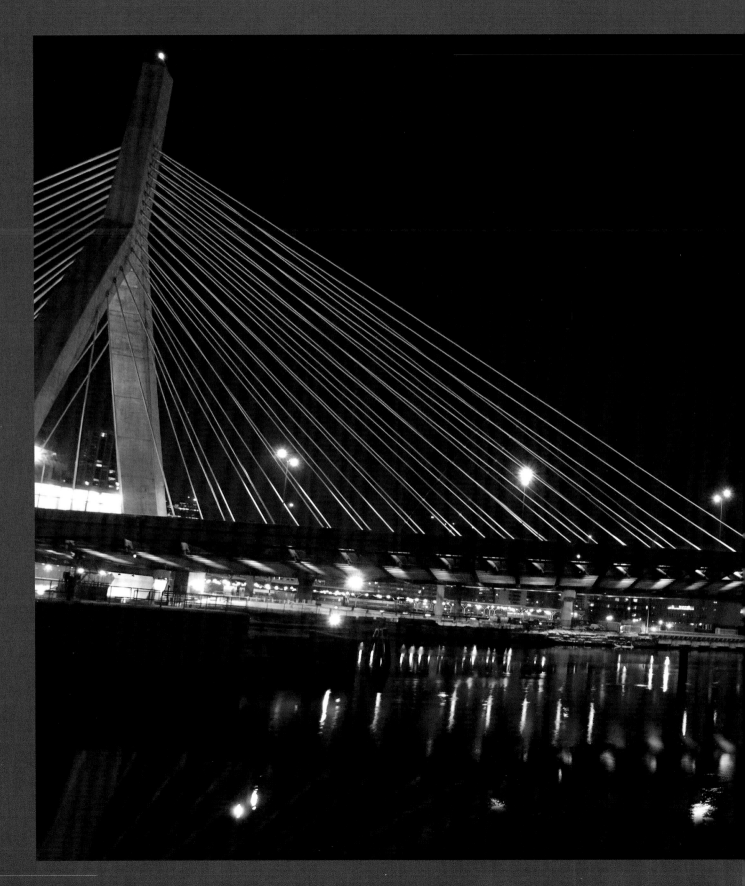

CHAPTER 8:

THE PLUG-IN WORKFLOW

There are various plug-in software packages available that convert color images to black and white, and most of them are well worth the time it takes to sift through and try them. Many plug-ins replicate a certain look—like Alien Skin Exposure, which mimics the look of film. Alien Skin Exposure even includes accurate facsimiles of grain from film, and is detailed to the point of allowing you to adjust the grain size to mimic a specific format of whatever emulsion you want—choose anything from 4 x 5 Tri-X film to 35mm Tri-X. (Alien Skin Exposure can be found online at www.alienskin.com/exposure.)

NOTE: A complete listing of plug-ins for Adobe can be seen and is well worth a look:

www.adobe.com/products/plugins/photoshop

Many plug-ins act as filters, and are accessible via the Filter menu on the Photoshop navigation bar. Plug-ins often harbor a pleasant little surprise—many of them, when applied to a Smart Object, turn into Smart Filters. For more on Smart Filters, see page 224 in the Appendix.

Nik Silver Efex Pro

Nik Software has a great, full-featured black-and-white conversion plug-in called Silver Efex Pro, and all Nik software supports the Smart Object workflow (www.niksoftware.com). We'll use Silver Efex Pro to demonstrate the Smart Object plug-in workflow. If you'd like to follow along, Nik has a free 15-day trail version; I suggest downloading it and giving it a try.

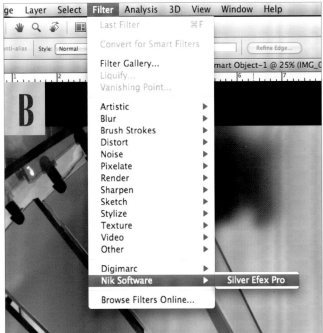

First, open the file as a Smart Object (image A). Then open the plug-in: Filters>Nik Software>Silver Efex Pro (image B).

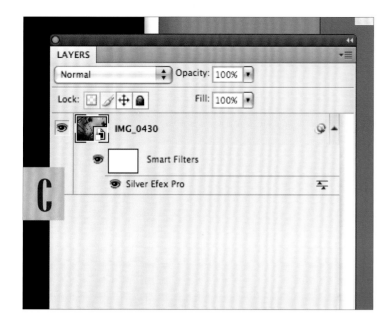

This automatically adds a Smart Filter to the image layer (image C). One of the things I really like about this software is the easy-to-navigate user interface (image D). It even resembles the Adobe interface; you don't feel like you just stepped into some strange new world, as you might with some plug-ins.

There is a nice thumbnail strip on the left—"Styles"—that shows you a a group of applied presets (image E). You can select one for preview. Also, if you make modifications to the image's settings, you can save those changes here as a preset.

The right column consists of image controls (image F). There are the "Color Filters" to simulate the effect of an optical color filter shot on film, as well as the "Film Types" pulldown menu (image G). The menu structure is easy and user-friendly: The small triangle arrows expand and collapse the main menus and the sub-menus, and the control panel is activated with a check-box. This is a common way to provide multiple controls and present them in a neat, organized way. Simply open the frames you need to work with and ignore those you don't.

Here's a detail of the panel for Tri-X film, with each color setting control and the grain and response curve shown (image A). The "Stylizing" panel accesses the various controls for applying film and paper-like effects (image B).

I'm using Tri-X with a red filter for this example (image C).

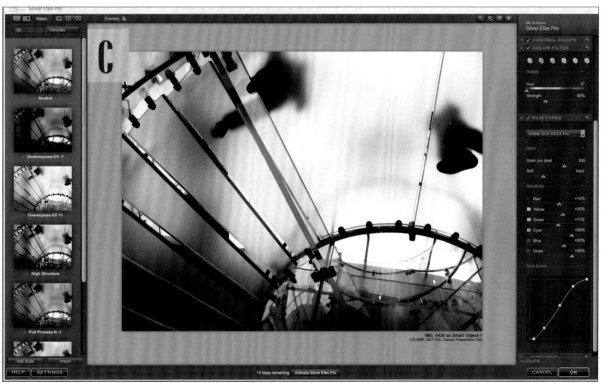

Nik has a few other controls—called "Control Points"—that make some very interesting localized adjustments (image A). Control Points are similar in function to Camera RAW's Adjustment Brush, but with a different control handle. Click "Add Control Point" (image B), and

in the image where you want to make adjustments. This is what you see (image C). The top "leg" is your diameter, and determines the size of the adjustment area. As you move down, you get Brightness (image D), Contrast (image E), and Structure (image F). As you adjust the Control Point, you see a preview of the adjustment and the full controls (image G).

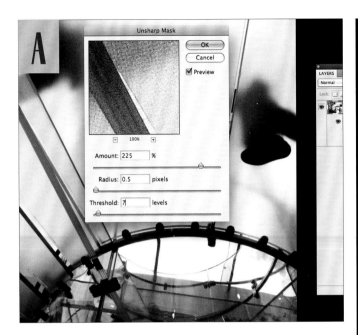

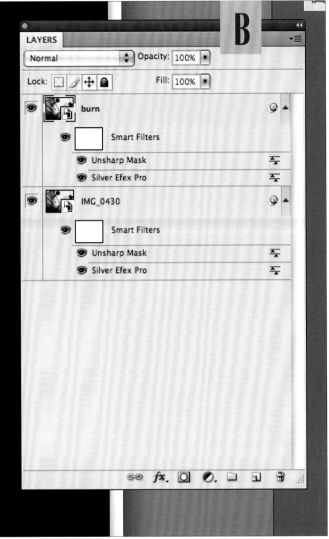

Finally, we apply sharpening. Nik has a sharpening plug-in as well, but we can also use Unsharp Masking as we have before. Close the plug-in window to get back to the image in Photoshop. Go to Filter>Sharpen>Unsharp Mask (image A). This is built as another Smart Filter on our layer; now we can use the same techniques we saw in our Smart Object process. Go to Layer>Smart Objects>New Smart Object via Copy, and there is a new layer with all the filters already applied. (image B). I'd like to make a burn move, so I open the new layer, adjust it, and apply a mask (image C).

Zone System Scale: On the bottom right of the plug-in window is a Zone System scale, giving you the option to select one or more of the ten Zones of gray (image A), and a gamut-warning style color overlay showing what areas of your image correspond to those values (image B). If you're a familiar with the Zone System, this will make you feel right at home.

Film/Filter with Plug-Ins

The plug-in process gives you a built-in variation on the Film/Filter workflow we've talked about. Check out my normal image (image A). I leave the Smart Filter alone and reopen the image in Camera RAW. Then I shift the color balance to blue (image B). When I hit OK, the Smart Object image is reprocessed into Photoshop. The colors fed to the Smart Filter are different, resulting in a very different grayscale conversion (image C). The Smart Object color rendering is my "Filter" and the Smart Filter is my "Film."

Mapping Colors with Film Types: I want to be able to map my colors to values of gray the way I can with the Black & White adjustment in Photoshop and HSL/Grayscale in Camera RAW. This control is somewhat hidden under the Film Types frame. (If you're starting with a film type, you will have seen it; otherwise, it isn't very obvious.) If you start with a "neutral" film type, you get a zeroed setting (image A). Use this starting point as you'd use the other Adobe tools to individually control the luminance mapping of each color. You can see from my control panel that I've boosted the red hues (image B).

I can also open the "Tone Curve" frame and make a second mapping move (image C). This is an interesting combination; with one control I've moved the blue values down to the lower scale, and then down even further using the curve. You can do this in Camera RAW, of course, but it's not quite as obvious or as direct.

Silver Efex Pro is just one example of a package that works with a Photoshop Layer/Mask workflow, as well as working in the Smart Object/ Smart Filter RAW process. The more comfortable you are with film, the more likely you are to really feel at home with it. The plug-in developers have done a great job building excellent control into a nice, clean dashboard.

I suggest you give this and other plug-ins a look in building your process. Most, if not all of them, have trial downloads, tutorials, and great support. Keep the basic premises in mind, though: You're building a process and mapping colors to tones of gray.

BOOK 3:
DIGITAL BLACK-AND-WHITE PRINTING

The print is the final step—the performance—of the black-and-white process, and also the point at which we're going to move into another workspace. We're moving into the world of ink and paper.

Up until now, we've been working in the world of light. We see the light reflected from the subject, the sensor records light, the display shines light at us to show us the image colors, and we edit the image as light. When we make the print, we're moving to the physical world of ink.

In the darkroom, the transition from light to print was mysterious and almost magical. Chemical reactions made density changes in a silver halide emulsion and when projected onto another emulsion produced tones of gray. The need to learn to visualize the result was pretty obvious. You had to learn to predict the outcome, or you would be surprised—pleasantly or not—by the final print.

In the digital darkroom, we're lulled along the way by the feeling that we'll get what we see on the display. Of course, that's impossible. No matter how good the controls are or how accurate a color display, we still cannot see the results of a light-based image on paper.

Understanding how we move from the world of light into the world of ink and paper is the last piece of the puzzle and the last step in building a process of visualization.

CHAPTER 9:
PRINTING BASICS

Photoshop-Managed Printing

Before we go into the black-and-white printing process, let's review a solid color managed workflow for printing RGB color files. From Photoshop, go to File>Print to get to the main Print window. In the upper right corner under the Color Handling window, select "Photoshop Manages Colors" (image A). Just beneath that is a pulldown menu where you can select printer profiles. I've selected the Premium Glossy Photo paper profile for the Epson R2400 printer.

NOTE: It is critical that you select the correct profile for the exact paper and printer combination. This is not a case where "close enough" will do.

After making the other selections, such as centering, page size, etc., hit "Print" to go to the Epson printer driver settings (image B). Select the Print Settings from the menu and you get to

this dialog box (image C). Select the paper type, and then select "Off (No Color Adjustment)" in Color Settings. Now you are ready to print.

Driver-Managed Printing: Epson Advanced Black & White Driver

The process of sending an image to the printer through Epson's Advanced Black & White option is a bit of a curveball from the normal Photoshop-controlled color managed workflow. For color prints, you would typically use Photoshop to make your color management decisions and turn the Epson controls off to avoid double-correction. When printing in black and white, the best solution is to use the Advanced Black & White controls and allow the printer driver to control the printer, rather than Photoshop. Epson has worked hard to make these controls as precise as possible, and has created a very nice path for making black-and-white prints.

Get to the printer in the usual way: File>Print (image A). When you reach the main screen, make sure the Color Management option is selected and pick "Printer Manages Colors" (image B). Select Print and this is the next screen (image C). Select the Print Settings and pick your media first (image D).

NOTE: The media type determines your access to the Advanced Black & White controls. Epson allows only premium papers for use with the Advanced Black & White driver. If you are not using a premium paper, the Advanced Black & White option is grayed out.

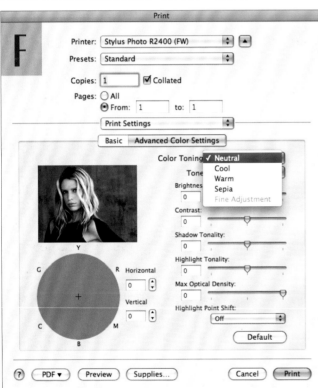

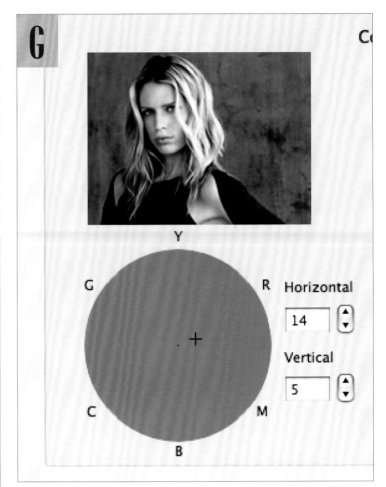

Once you have determined your media, go to the Color Controls and select Advanced B&W Photo (image E). This will default to some basic settings that are changed through the Advanced Color Settings tab (image F).

First, decide on the Color Toning. I usually go with a neutral tone—no additional warming or cooling—and I select that under the Color Toning drop down menu. If you want more control you can select a tint on the color wheel (image G), which looks like the color tint wheel found in some third-party RIPs we'll see a little later. This lets you apply virtually any color tone you want to the image.

The next drop down menu is the Tone selection, which defaults to "Darker" (image H). This specific Tone selection is a very linear selection—it does not apply a curved adjustment to the file. The other Tone settings—Darkest, for example—apply more of a curve adjustment to the image. Interestingly, the Darkest setting doesn't really change your shadows or highlights; it lets you simply map the midtones down a bit. The Dark, Normal, and Light selections also act like curves, but they lighten the image slightly. Again, the curve doesn't touch the extremes; it just remaps the middle values.

Below the Tone menu is what I like to call "curve controls." These are similar to the slider controls in Photoshop. The Brightness and the Contrast sliders theoretically control the middle

of the curve, with a little more range and control than the "Tone" selection (image I). I say "theoretically" because there is no histogram, curve window, or preview other than the image preview window that has no relation to the actual image, so I don't know exactly what is adjusted or how. Thus, I leave these controls at default.

The solution that some have come up with is to develop a series of standardized adjustment curves that can be applied to the image file after editing in order to keep the printer performing consistently. Eric Chan, of MIT and Adobe, has put together a great resource which can be found at: http://tinyurl.com/cwc5l7. The idea is to adapt the Epson Advanced Black & White driver to different types of paper.

Here's my take on how to use these controls. First, if you want a color tone or tint in your prints, this is a good place to apply it. The drivers produce a nice and consistent ramp of color tinting throughout the tonal scale—something Photoshop won't do. If you do try to tone the image in Photoshop and print it this way, the Advanced Black & White driver will ignore the color toning and try to print the image as a grayscale image. Your only choice is to use the color drivers and the usual color-managed workflow.

Second, do some testing and make some basic selections that you're comfortable with in this window. The idea is to get to the point where what's coming out of the printer matches what you see on the display and in the histogram. That shouldn't be too far from the default setting. Save the settings you make as a Preset (image J). Apply the Preset when you print and use the same settings to get consistent results.

If this works, and you're happy, then you're done. If you are switching papers and find that those you're using perform differently from each other with unpredictable results, then you can try Eric's approach. Apply some correction curves or simply move to the next chapter to learn a higher level of control: Printing with a RIP.

Choosing Paper

It was very excited the first time I was able to design and print my portfolio in a magazine format with my ink jet printer. Yet, the printer wasn't what got me excited; it was the paper.

For the first time in my photographic career, I could print on a large variety of papers, including an assortment of watercolor-like stock. This brought me back to my lithography, mezzotint, and silkscreen printmaking days, printing my photographs on paper that felt like true printmaking paper. I wasn't stuck with a plastic photo paper or even a fiber photo paper that had a gelatin emulsion. I could print on real paper.

One of the first things I tried to do was print on regular, off-the-shelf watercolor paper. You find out pretty quickly that the results are less than stellar, because watercolor stock is quite absorbent and ink jet printers don't shoot much ink. Those tiny droplets are sucked right into the paper and can all but disappear. A large part of the ink jet paper evolution has been about that challenge—how to print and keep droplets of 4 picoliters visible and vibrant. The answer is rooted in an old dye and fabric technique: mordanting.

A mordant is a substance used to set dyes on fabrics. It binds the dye, forming an insoluble

compound. Ink jet papers use a type of coating on the paper that does just that—binding the ink on the surface of the paper to keep it from soaking in—but it also creates a chemical compound that gives it permanence and resistance to water and abrasion. Interestingly, this coating is partly ceramic, and even more interesting, the early ink jet papers used one of the most primitive materials on earth: clay.

This has created a tide of papers that have slowly approached the standard we all look for—a print that rivals and surpasses the deep blacks and luminous whites of a good silver paper.

Today, there is a large selection of papers to suit almost any photographer's preference, and the selection continues to grow. The choice is now less about settling for a good paper and more about finding the paper that fulfills your vision.

Brooks Jensen, the editor of LensWork, talks about an interview he had with photographer Oliver Gagliani about papers. The comment I remember him making was that a good paper "sings"—it has a voice much like a fine violin. A superior violin can carry over a long distance, as Gagliani described it. So can a fine print, made on a fine paper.

This speaks to the personal, almost emotional process of selecting papers. Every photograph or series of photographs has a perfect vessel—the medium that best carries it to the viewer. The only way you can know what paper is best is to try them out. Make prints, comparing how one image looks on a variety of papers. Keep in mind the surface texture, the brightness of the whites, the deepness of the blacks, and the separation in between. You're not judging which paper fulfills these criteria, but through these qualities, which paper best suits the image. In all the testing and trying, however, remember to bring this back to our emphasis on process.

Vision develops through understanding what your tools are capable of. Visualizing a paper's response to your image requires that you know that paper, and you cannot know every paper on the shelf. Once you have experimented, make a selection and stick with it. You may love it, or after a few months of in-depth use, you may decide it doesn't work they way you need or thought it would, and you have to start the search all over again. But make the decision deliberately and with commitment.

Gamut

What are the characteristics that make a paper perform, and what gives it it's certain "voice"? The single most important factor in how a paper is going to look is the paper's gamut and the ink combination. Gamut is the range and

depth of color that the paper can reproduce. When you build a paper profile, you can see the gamut—the color space it can handle—on any software that can show a gamut map.

Below is a gamut map comparison of Epson Enhanced Matte paper (the solid, smaller lines), and Epson Premium Luster paper (the larger, more transparent color group) shown with the gamut-mapping program ColorThink. (The gamut map is a tool that plots the color-handling abilities of various mediums, in this case, paper.) The Premium Luster paper can clearly print deeper blues, purples, and reds than the matte because it has a bigger gamut.

dMax

The most important thing gamut refers to in terms of a black-and-white image is the maximum density of the blacks—the dMax. The deeper and darker the black is applied to the paper, the richer the print will appear. This is a measurable value. Color management systems that profile paper can also make straight density

measurements, and you can see for yourself the results from different papers and even different printing methods.

Like many other things we've talked about, dMax is barely perceptible—the difference between two papers may be something you can only see when they are laying on top of each other. But subtle differences can produce remarkable results, especially when several subtleties are combined into one result. One aspect of a paper that can enhance a good dMax value is paper brightness. "Paper white"—with no ink dot at all—is the brightest white a paper can be. If a paper has a bright white and a deep black dMax value, the print will have a wide range of tones and will "carry." A paper with a low dMax and a dull white will create a flat print.

Brightening Additives

Another element sometimes added to ink jet papers is called Optical Brightening Additives. These are additives that absorb, shift, and reflect light at a different wavelength, essentially acting as a fluorescent. This is tricky for many reasons, the most significant problem being the longevity of these agents. They can threaten the permanence and appearance of the entire print. Other issues include inconsistent response to various viewing lights, as well as color management problems. These brighteners can also cause problems with any system that is trying to read them as targets in order to build a paper profile. From an archival standpoint, paper with optical brighteners should be avoided for fine prints.

Paper Surface

The surface of the paper is a big issue as well, but one that should be considered in context of the final image. Photographic prints are no longer limited to the plastic surface of a resin-coated

paper or the gloss-shell coating of a fine fiber paper. We can print on literally any surface, from a toothy watercolor to high gloss photo paper, to thinly transparent rice paper. This can quickly turn into a candy store of choices, so I suggest trying out a paper if it's interesting. Most manufacturers sell sample packs; it's well worth the time to go through them. Keep in mind that the surface has a great deal to do with the dMax and the whiteness of the final print. Even the thickness of the paper has an impact on these characteristics.

Do yourself a favor and go down that experimental road, but remember to bring it back to the process. Decide on a few favorites and get to know them. Without knowing and understanding your paper, you can never close the loop and really learn to visualize the print.

Baryta Papers

Bartya papers harken back to some of the glorious silver papers of the darkroom days, and have recently joined the ink jet printer arsenal. This is big news.

Baryta is another type of mordant—it's a barium-sulfate compound, much like clay—bonded to a fiber-based paper substrate. It gives you very high reflectance, and thus a very bright white, without introducing optical whiteners. It's particularly helpful when it's used on a flat matte surface—cellulose paper or a 100% rag paper—to enhance the contrast and dMax of the more absorbent paper bases. (Gloss papers have less of a problem with this since the coating and the base performs much of the same function as the mordanting.)

Printer Developments: The Durst Theta 50 B&W

Some current examples of Baryta papers are Hahnemuhle Fine Art Baryta 325, Harman Gloss FB AI, and Ilford Galerie Gold Fibre Silk. The papers have been getting great reviews and are steadily gaining acceptance. Back to Mr. Jensen—with the release of these new papers, he feels confident that he can produce a print of acceptably high standards—his standards—using these new papers.

I have little doubt that within a fairly short time, you'll see a larger selection of Baryta papers available from many more vendors, including the printer manufacturers.

These tests are very interesting. Below is some work by my friend Tyler Boley, and I'm showing you a screen from his site, www.custom-digital. com, for that one line I love—"Warning! Obsessive discussion about dots of ink follows." This example shows that at a microscopic level, silver printing—the traditional darkroom process—still produces a sharper, more continuous tone. How does that apply to our digitial workflow? One answer is the Durst Theta 50 B&W.

Here is a bit of background for context. The Durst Lamda process uses a laser light source to expose light-sensitive paper. To bring it back home to the darkroom, it's essentially a laser

WARNING! Obsessive discussion about dots of ink follows–

Film Scan ABW 1440 Quad 1440 K7 2880 Silver Contact

The Theta 50 B&W is a smaller, dedicated black-and-white printer that uses lasers to expose slightly modified but essentially traditional fine photographic paper. Eric Luden of Digital Silver Imaging showed me theirs, and I was taken right back to the smell of my grandfather's darkroom and all the years I spent hanging over the trays as soon as he opened the tanks.

Granted, this is not a system that everyone can run out and pick up for their home darkroom, but it is out there and it brings up some interesting points. The first is whether these prints compare to traditional enlarged prints, and the second is how they stack up against the other methods we've addressed.

There is another issue as well. Bill Gallery, a masterful black-and-white photographer, spoke to me about printing with Photoshop compared to the traditional darkroom. He said flat out that whatever printing method you use, the control you have with Photoshop just simply makes the darkroom obsolete. Whether you like silver prints or not, Photoshop's image preparation for printing is unparalleled. This print method satisfies the needs that Gallery has to render his image, and it satisfies the silver purist who feels that the best print possible is a silver print processed in the darkroom.

enlarger. You send a digital image to the printer; it shoots lasers on to a traditional photo paper, and you process the paper just as you would in the wet darkroom. It makes a continuous tone print, and for a long time it was the standard that all digital printing was measured against (along with the Cymbolic Sciences "LightJet" printer, a slightly different way to deliver the laser to the paper, but essentially the same concept).

CHAPTER 10:
AN INTRODUCTION TO RIPS

A RIP is another fundamental way to control the printer. RIP software presents photographers with a long and winding road, but what a RIP is and does is very interesting. "RIP" stands for Raster Image Processor, and its basic function is to take a raster image (also called a bitmap image, which is simply an image made of pixels) and interpret it as it would be rendered in dots of ink. Let's look at what is happening under the hood and the available controls that come with using RIPs.

One reason we want access to these controls is that standard manufacturer's print drivers are very generalized tools, and are designed to give most users most of what they need in an easy-to-use package. A RIP provides very specific printing choices, but requires a learning curve. Maybe, instead of creating the highest quality print as most photographers want, you'd like to simulate what an offset press would do to color on newspaper stock. Or perhaps you want to print stunning grayscale, with deep and

have built solid reputations. Some of these companies started as simple PostScript processors. (PostScript is Adobe's proprietary image language that describes a vector image; a RIP uses PostScript to create a bitmap file that a printer can recognize and reproduce.) These processors gave you a way to process and print vector files—like illustrations and type—and were aimed primarily at the prepress and design market. A few RIP programs emerged from those original PostScript processors as fine photographic printmaking tools; we'll look at three here—ColorBurst RIP by ColorBurst, the Imageprint RIP by Colorbyte, and the QuadTone RIP by QuadToneRIP.

The ColorBurst, Imageprint, and QuadTone RIPs are primarily ways to use a standard, color-channel ink printer to create good black-and-white prints. The QuadTone RIP also accommodates printers that have been converted to dedicated grayscale machines by replacing the color inks with shades of gray. I'll go into the ColorBurst RIP first as an example of how it works and why, important features

separated shadows, clean and detailed high-lights, and an evenly toned ramp from black to white. A RIP allows you to tailor the controls of the printer for very specific output, such as fine black-and-white printing.

There was a period when RIP companies came and went quickly. Now it seems the market is more stable; a few companies still exist and

and their purpose, and give a quick nod to the Imageprint RIP. I've dedicated the end of this chapter to discussing the QuadTone RIP and using grayscale inks.

ColorBurst RIP

Most RIPs act and look like a printer on your operating system. ColorBurst shows up as a selection in your printer menu when you install it, and you can select ColorBurst RIP—just as you can select Epson R2400 or any other printer—when you start the printing process. When you install ColorBurst and Imageprint, follow all the initial setup procedures.

Here's the first step in ColorBurst (image A); select the printer and the "Environment". The Environment is a "Settings" file that saves several parameters in one step. I've set this environment up for the Epson 7600 by selecting the 7600 Gray Premium Luster Environment. Out of the seven selections in this screenshot, three are for grayscale.

Two sections allow you to change the default Environments: Printer Settings and Ink/Color Settings. Printer Settings (image B) is where you change page, paper, and layout decisions.

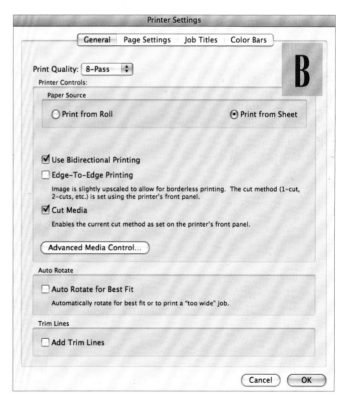

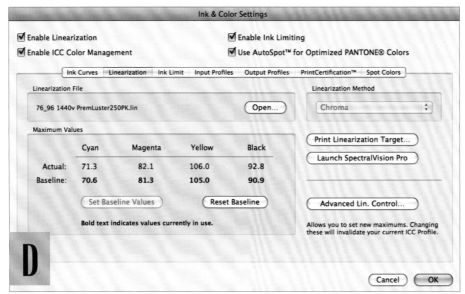

Ink & Color Settings (image C) is where you make significant decisions about how the ink is applied to the paper, and uses basic controls over the most fundamental processes. You can see and precisely control the ink channel curves for a set environment. The Linearization tab (image D) allows you to recalibrate the printer's linear response—an essential first step to building a good printer profile. Linearization essentially sets a baseline for the printer to ensure it gives a consistent output (meaning it prints the same "black" each time you direct the printer to print "black"). Linearizing the printer requires a system and device that can read the values of a printed target—like the X-Rite i1 Pro Spectrophotometer—and the process is controlled and integrated into the RIP.

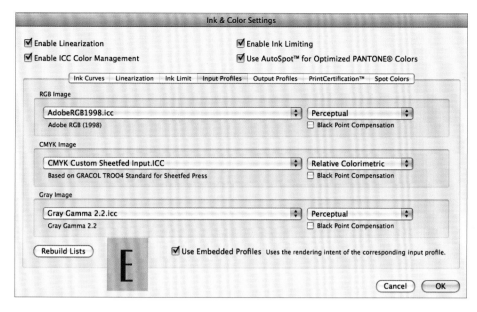

The next tabs take you to the color management settings, which control the way the software handles the color spaces of incoming files (image E), and the specific output profile it sends with the file to the printer—in this case, a profile called 76_96 Gray PremLuster 250.icc (image F).

These are standard color profiles (called ICC profiles) and you can see the extent of them here (image G). You can also build your own profiles if you want to, again with a Spectrophotometer and color management profiling system. I'm saying "want" quite deliberately and not "need" because usually the supplied profiles are quite good for most papers and printers.

This is what the main window of the RIP looks like (image H), and this may give you a sense of its roots in the prepress-production industry. An interesting side effect of running a RIP is the queuing and workflow management possibilities. You can set up, queue, hold, repeat, and store

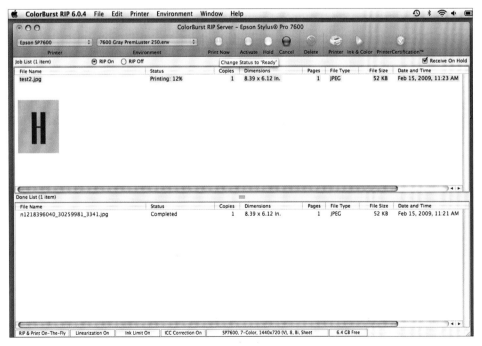

print jobs—a very important feature in a production environment, but maybe not so important to individual photographers.

These are all controls that you can go into, but don't necessarily need. By default, the grayscale Environments are impressive, and many people never take it any further. The current Epson product line is so linear, that even the linearization isn't often done.

Imageprint is also a very powerful and reputable package, and has a nice preview window to show us our results (**image A**). For more than a few people, this preview is enough to sway them toward this product. It also has all those

other nice controls mentioned with ColorBurst, as well as a Tint control (image B)—much like the tint control in the Epson drivers. (Actually, the Epson drivers are much like this, since this came first.) ImagePrint and ColorBurst are two very similar products that make very similar results. In my opinion, it just comes down to which interface you prefer.

The root of the issue is back to what we've said in the beginning. This software is a very specific control for getting results from the printer without compromise. Well, except for one little compromise: We're still trying to make a black-and-white print with a color printer. The next step down the path is to look at grayscale inks.

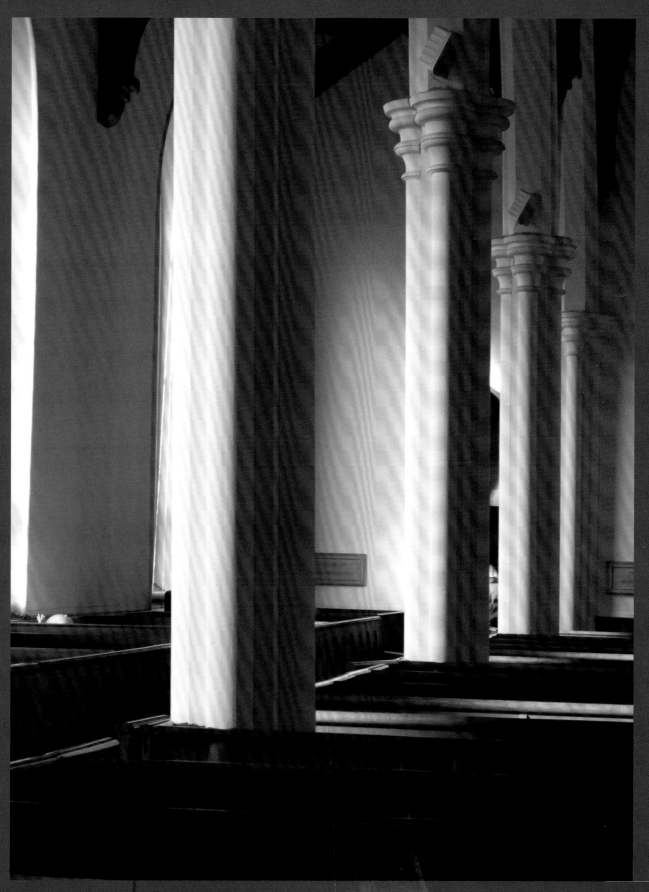

Grayscale Inks and the Quadtone RIP

So far, we've been wrestling with the best way to create a grayscale image with a color printer. There are many color channels, but only three possible grayscale channels.

We're leaning pretty heavily on those three channels to make up the entire tonal palette as well as the resolution of the print. A printer with eight nozzles spraying little droplets of inks makes up the little tapestry that is a color image. When you ask that same printer to print with only three nozzles, you're using a third of the available ink.

One solution to replace the color inks with gray tones. Early entrants into this market are still around and now offer very refined products, methods, and support. The Cone Piezography and MIS were two ink system pioneers with this approach, and they are still at the top of the game. There were some pretty interesting attempts to control this system type but what has settled out is a RIP specifically designed for driving this third-party configuration. The QuadTone RIP has been accepted by some of the major players as a high quality solution for controlling these ink sets.

UltraChrome K3 Piezography K7

There are examples from the Cone Piezography site that make a pretty good case for this system. First, on the resolution issue, here's a very impressive test they did a while back: They took an excerpt from a book and printed it in 1-point text on both systems. Here's what they started with (image A). Here's the side-by-side comparison of the standard Epson driver and the Cone/QuadTone RIP system (image B). Note the dots

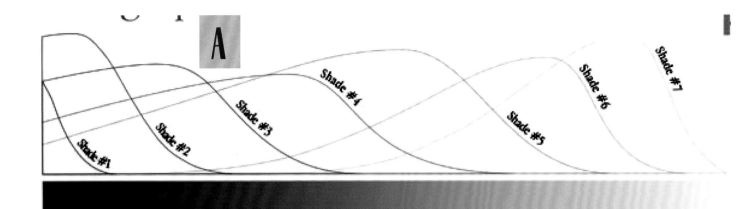

of color in the Epson system that almost looks like aliasing.

Keep one thing in mind here. Although you are seeing a comparison between the Epson Advanced Black & White driver and the QuadTone RIP with the grayscale inks, we're not seeing a comparison between one RIP and another using the standard inks—for example, the QuadTone RIP against the ColorBurst RIP. One of the main points John Cone wants to make is this: If you're not using grayscale inks, you're introducing color. If you're introducing color, it can fade and shift in different light. If you're using a monochrome ink set, it gives better resolution, better tonality, and a archival-quality print.

Just for reference, this is how the seven shades of gray break down (image A), and their Epson equivalents (image B).

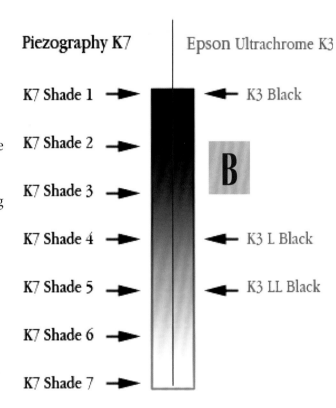

QuadTone RIP

Here's a brief introduction to the QuadTone RIP to give you a taste of that process and a hint of the power of that system.

Once you install the RIP it loads, as we've seen with ColorBurst, but this time with no main window or "application" interface. Load it, select it as your printer, and control it the way you control the Epson print drivers. Here's the System Preferences Printers window showing the RIP, configured for the Epson R2400 (image A). In this example I've installed and selected the Epson R2400 with the standard color Ultrachrome inks. In the Print menu, assign a profile for the RIP—QTR_RGB_Photo_Paper (image B).

Once you hit Print and are in the printer dialog, select the RIP version of your printer and go to the QuadTone Rip selection (image C). This is the main control window (image D); the first thing to do is select the curves you want to use (image E). The typical scenario is to select a neutral curve and then grab a curve with a slight warm or cool tone. You then can dial in the balance of these curves, tailoring the tone to what you envision for the image.

The RIP uses all of the color channels to reproduce color, but primarily the three gray channels. The first curve is the neutral feed and will use mostly the blacks and grays with a slight tint to overcome any non-neutral casts in the native black ink. The second curve feeds in more of the colors to add tinting and resolution to the image.

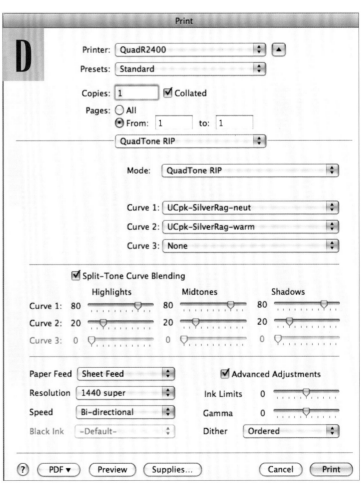

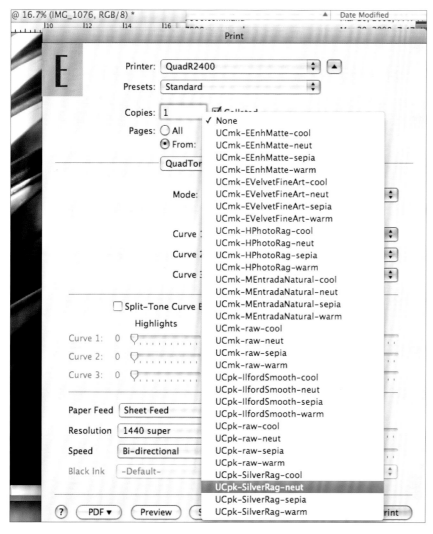

If we go back and load the version of the printer that has the seven dedicated grayscale inks—in this case the Piezography K7 ink set—it's called QuadR2400 K7 and it looks like this (image F).

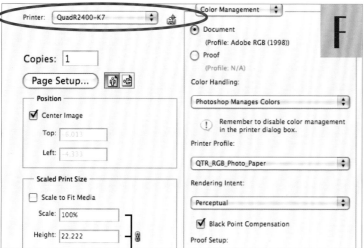

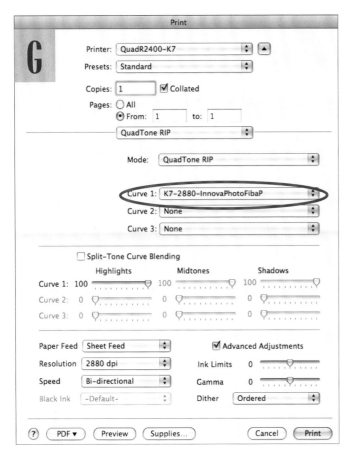

The curve is simply the basic selection for the printer and the paper—in this case, Innova (image G).

The secret of the QuadTone RIP is the way the curves are built and blended. With the basic stock ink setup you can do quite a lot with toning, and with a monochrome ink set you can specifically control which channel is used to build what tone and how. The purpose of this is to combat the tendency for separate ink channels to reproduce an uneven or banded grayscale ramp. Blending the curves is the solution to that problem.

The QuadTone RIP isn't the most intuitive system; it requires testing and adjusting to get results you expect. The application has a few tools to help build the system to your taste, and you can find some pretty helpful information at www.quadtonerip.com, including links to user groups, ink suppliers, and other resources.

Ink Systems

Assuming you're running a current printer and the QuadTone RIP, there are two main routes to go take for running grayscale inks. Cone Edition's Piezography has been around for a while and has achieved as close to a cult status as any printing method could. Jon Cone was instrumental in evangelizing this method and deserves a lot of credit for where these systems are today. That's not to say it's been a smooth road, though. Much of the process was experimental and I've heard more than a few complaints about being paid to "beta test" a new ink or process. Fortunately it seems that is behind us, and the Piezography system is arguably at the top of the pile for the finest black-and-white printing process.

MIS is another company that has been a source for grayscale ink sets. They're a bit broader-based, catering to the fine black-and-white market as well as to other bulk-supply inks and printer products. Paul Roark has been the driving force behind MIS's black-and-white development, and the system is often mentioned in on-line discussions as a great, less-expensive alternative to the Piezography system.

You have a few choices when getting started. First, you can decide to simply replace your current color ink cartridges with the Cone inks or add a bulk ink feeding system. Bulk ink adds a set of bottles and tubes to your printer, and because you're buying bigger quantities of inks, you're paying less for the ink and getting more prints-per-gallon. My advice is to try out the cartridges first. You can always switch to bulk feed later.

The second decision you need to make is what color or tone of ink you prefer. Cone offers the standard neutral inks as well as other hues: Warm Neutral, Carbon Sepia, and Selenium. MIS offers Carbon, Medium Warm, Neutral, and Cool inks. This is a decision you have to give some thought to, and although you can switch out inks pretty easily in the smaller printers, the bigger printers use up a lot of ink in the flushing/charging process. Unfortunately the only way you can actually see your work printed with different ink sets is to try it yourself. If you're running a big printer, it is certainly worthwhile to pick up a small desktop printer and try the different tones out before loading the big one with ink.

Getting started is not much more complicated than that. Several inexpensive printers support Cone inks, such as the humble Epson R220 (under $100), and the Epson 1400 printer—under $300 and capable of handling 13-inch (33 cm) wide paper—supports both MIS and Cone.

Archival Issues

One last thought, and by no means an afterthought, is the issue of permanence. Although the Epson Ultrachrome inks are touted to have over a 100-year rating for permanence, that claim has been the subject of heated discussion. Introducing a slight bit of color ink, and notably yellow (the first ink to start fading), into a black-and-white print suggests that UltraChrome inks may not have as long a life as is claimed. That is certainly the objection raised by both Cone and MIS. The grayscale inks are manufactured from carbon black, one of the most archival materials on earth, and the tests done by both RIT and the Wilhelm Labs show that these inks fade about half as much as the Epson UltraChrome inks in a 100-year comparison test.

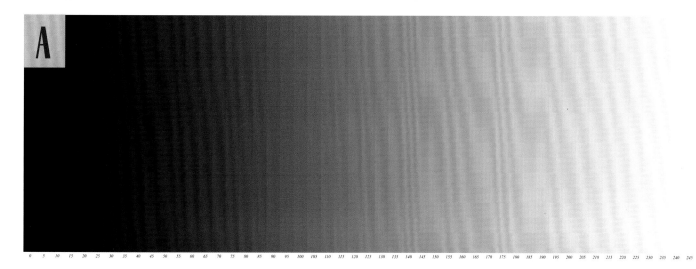

0 5 10 15 20 25 30 35 40 45 50 55 60 65 70 75 80 85 90 95 100 105 110 115 120 125 130 135 140 145 150 155 160 165 170 175 180 185 190 195 200 205 210 215 220 225 230 235 240 245 250 255

The Step Wedge

We've gone through conversion methods and ways you can print black and white. Now do one simple thing: Print the step wedge (image A). Go to my website, http://www.teddillard.com/graphics/step.jpg to download the step wedge.

This very simple exercise will give you what I feel is the most crucial link in learning to visualize: an actual representation of what you're seeing on the histogram. Using the grayscale conversion workflow, the printing system, and the paper you've decided to test, open the step wedge, print it in the way you will print your black-and-white images, and look at it.

Here's what you should be seeing in the shadow areas (image B). Although you're seeing values that approach pure black—the "0" patch—you should be seeing a very faint line of separation between the black on 0 and the black on 5. As

0 5 10 15 20 25 30 35 40 45 50 55 60 65 70 75 80 85

5 240 245 250 255

you move up the scale, you should be able to make out the patches more distinctly, right up to the highlights (image C).

0 5 10 15 20 25

235 240 245 250 255

The first reason I print this target is to find out what my printer/ink/driver combination is actually doing as opposed to what it should be doing. Running most papers—Premium Luster, for example—through the standard Adobe and Epson driver color management process often gives you this result (image D). I can't see a distinction between 0, 5, 10 and even 15; this tells me the values from 0 – 15 are printing the same value of black. The range, or curve, is compressed at the very bottom of the tonal values.

This is crucial information for adjusting, burning, and dodging my image, because if I think I have detail and separation in those areas but my printer doesn't render them in steps of black, then I'm not "seeing" my print. Here's another example (image A). Most Epson printers do this under any circumstances—they print values as high as 250 as a very light gray and not the almost pure white most calibrated monitors display. This is crucial. If I'm trying to get a luminous highlight by setting a value to 250-250-250, I'm actually printing gray, and that is important information.

Here's another nasty thing that a lot of printers and papers will do (image B). I'm simulating this effect, but you can clearly see a few things happening. First, you're getting color shifts from black to white. Depending on the decisions about the print drivers and color management (mostly out of your control), the system may alter the color balance of the neutral scale by favoring a nice color reproduction. This is something we need to know, especially when working with black and white.

As you work with more sophisticated and precise methods, the step wedge should approach an optimum result. One of the purposes of the Advanced Black & White drivers, RIPs, and monochrome ink sets is to create a nice, solid ramp from black to white that remains neutral.

It is certainly worthwhile to print and view the results for yourself, especially under the viewing light you're printing for. Printing and viewing this sample under the appropriate light shows me exactly what I'm going to get in my final image for any target value. All the color management attempts to get to a state of "what-you-see-is-what-you-get" (WYSIWYG) with a digital display will never show you exactly how a particular paper and ink combination is going to reproduce tones. This can.

170 175 180 185 190 195

I have a printed step wedge on the wall next to my workstation, and a halogen track light shining on it. These are the viewing conditions for almost every print I make, whether it's going to be hanging in a gallery or on my own wall. If I'm concerned with a certain area's value, I'll go to Window>Info (image A) and put my cursor over that spot to see that this area of sky is reading 183-183-183 (image B). Then I compare it to that spot on the step wedge (image C).

Back in the darkroom, you had to guess. You made an exposure, waited five minutes to process it, and if you were smart you had a small sample of pure white and pure black that you could hold up against the test print you made. Then you had to take into account the dry-

down—the fact that wet paper shows highlights brighter than they appear when dry.

Then, we had the idea of WYSIWYG—that an RGB display could somehow accurately deduce the results of ink on paper under a certain viewing light, which turned out to be misguided at best. This simple step wedge target shows exactly what to expect from any given value on your image, period.

Visualizing the Process

By this point, you have hopefully determined your preferred conversion method, created a solid foundation in burning and dodging, gained an understanding of Camera RAW, and maybe tested some favorite papers with the step wedge. Now it's time to go back to the very beginning and learn how to see.

Let's start with opening the Histogram window in Photoshop: Window>Histogram (image A). Go to the little Palette Options button (image B).

Select "All Channels View" and this is what you get (image C). A histogram is simply a graph of the pixel values in an image. The horizontal scale is black to white from left to right. The vertical scale is the number of pixels. That's fine, but how do you use it? Look at this (image D).

This is the step wedge dropped into the Histogram window, and shows the values of black, gray, and white as they fall on the histogram. I don't know why Adobe doesn't do this for you in the Histogram window, but this a useful way to show what that graph actually represents.

Without even looking at the image itself I can tell that I have a lot of pixels that are very dark, a fair amount that are light gray, and none that even approach pure white. I use that information to decide if this image rendering will suit my vision for the final print. I want a clean, pure white. I can adjust that in Camera RAW by moving the image highlight values up to 250 or 255.

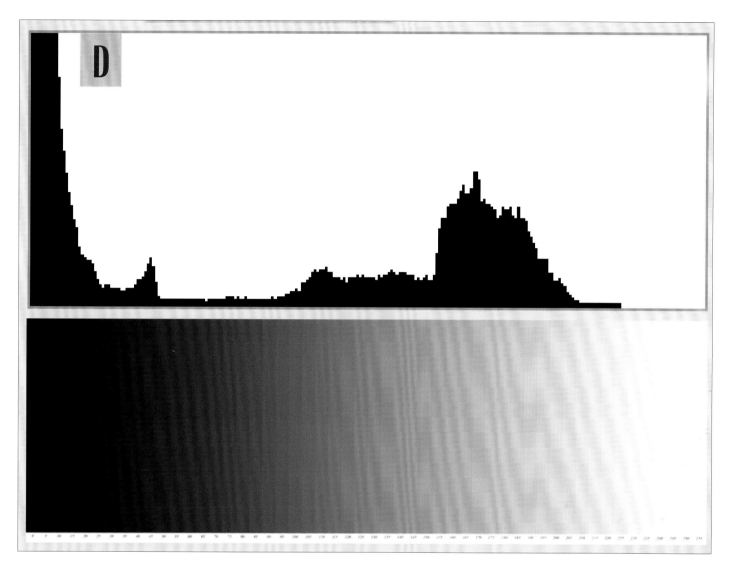

Now my choice is how far to go: 250 or 255? That's easy. Go back to the printed reference you have. That reference print gives you a good idea of what the printer will produce for that value of 250. You can make this decision based on what you see and not what you guess. That's the first step. Let's take another step, but backwards in the process to Camera RAW.

I've just done the same thing in Camera RAW (image A). The histogram at the top of the Camera RAW adjustments menu isn't quite as simple since it overlaps three channels and mixes the colors where they overlap. Look for red, green, and blue to figure out where and how they fall based on the colors they mix. (If you "Convert to Grayscale," the three channels combine into one.) Again, I've dropped in the image of my step target just for this illustration so you can see how the Camera RAW histogram will reproduce and how each channel falls on your scale.

Remember we're talking about the scale of luminance. Because we've printed the step wedge, we physically see how the color channels translate through the entire system. We see the values of each channel, how they translate to luminance

in Photoshop, and how they are reproduced in the print. Now let's bring it all together.

This is a camera's LCD monitor with the histogram turned on (image B), and I've dropped in the little step wedge. I can see how the actual values in my exposure will fall on the gray scale. If I know how the camera maps tones, I know how Camera RAW will map them and how they will look in Photoshop. Because I have printed the steps on my preferred paper, I know how those values are going to reproduce in a print. After I do this a few times, I can visualize the final print from this little histogram on the camera.

Standardize your process. Test the results. Use those tests to understand each tool at every step. Train yourself to visualize the final print.

CHAPTER 12:

THE FULL BLACK & WHITE EXAMPLE: CAPTURE TO PRINT

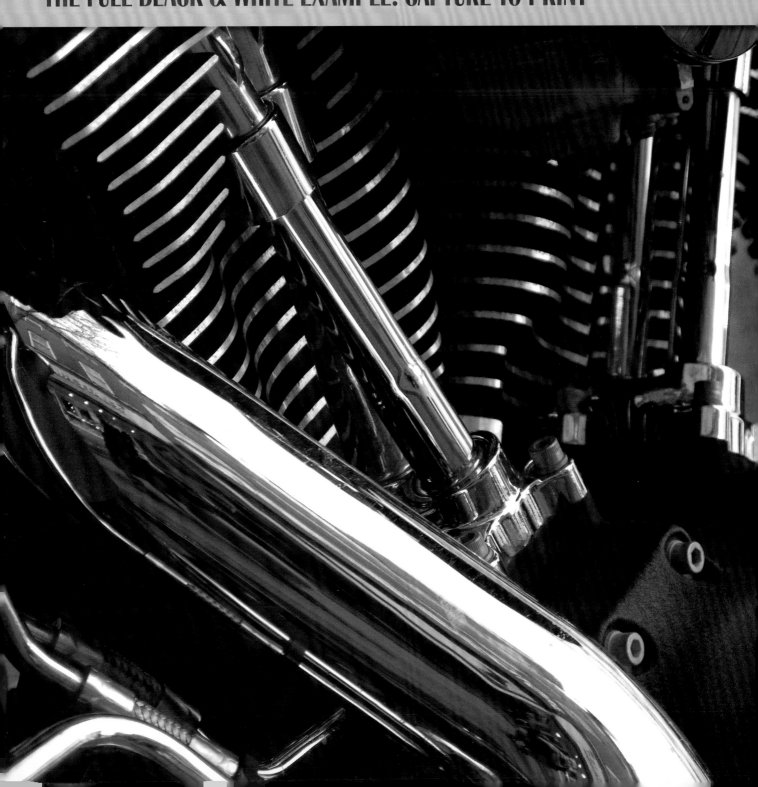

Here is the entire process from start to finish—at least, this is my entire process. It works well for me, but it is by no means the only method. I'm throwing in some of my favorite steps—some of these adjustments I always make and some I don't. For a description of the detailed steps, refer back to the appropriate section.

Part One:
Sorting and Setting Up in Camera RAW

My camera is set and the histogram is displaying my standard processing. Keeping in mind what the printer will do to gray values, I make my exposure using the exposure value compensation (EV+ and EV-) settings. I download a

pile of images and pick out the few that I'd like to process. My first step is to look at them in Bridge (image 1.1). I make a standard grayscale conversion in Bridge to get them all to black and white; I select the images to convert, go to Edit>Develop Settings, and pick a preset

that I've built (image 1.2). In this case, I've called the preset "txpD76," which favors the red channel. This is what I see once Bridge processes the previews (image 1.3).

This view makes it easier to see what I'm working with so I can make a final selection. I decide on the file (image 1.4), and double-click it to open it in Camera RAW.

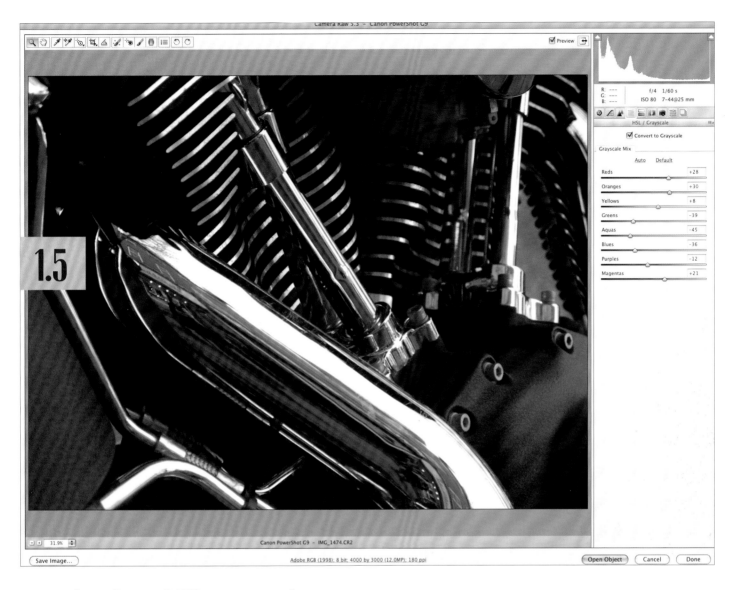

I have Camera RAW set up to use Smart

Objects (image 1.5).

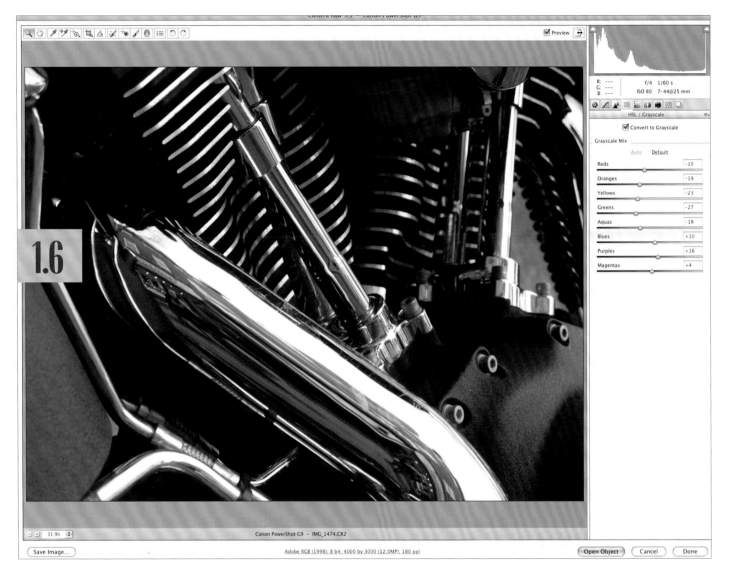

Now I play with the tone mapping (image 1.6). Look at these two samples. The first is my standard preset, the second is the "Auto" setting in Camera RAW. I'm playing around to get a handle on the image, what the conversion is doing to color tones, and where I want to take it. It's easy to toggle back and forth and mess with the sliders a bit to decide how I want it. I can look at a straight, linear conversion by clicking "Default" or see (image 1.7),

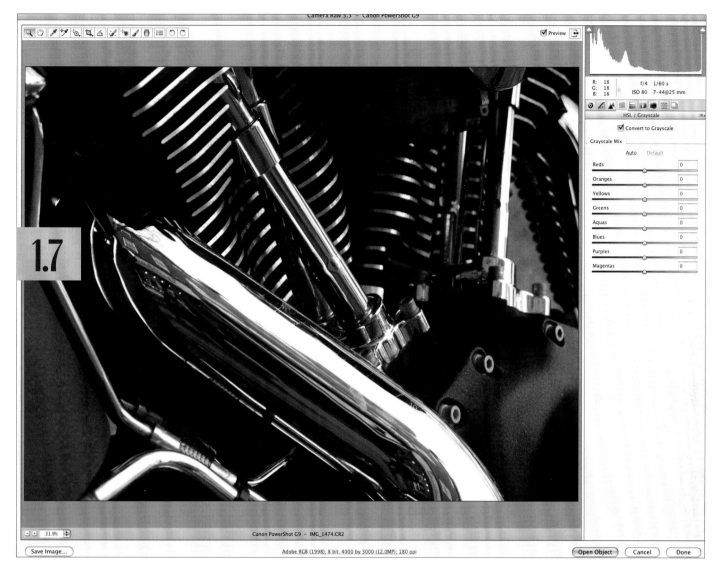

a preset as the default. I can go back to my pre-
set by choosing Image Settings>Apply Preset>
(image 1.8).

Or I can shortcut to the first conversion settings by unchecking the "Preview" button, (image 1.9 & 1.10). (This is helpful if your first conversion was not black and white and you want to jump back for a second to see what a particular color is so you can map it.)

Once I'm happy with my conversion, I create a Snapshot so I can save and refer back to the different grayscale conversion options. Go to the last tab, and click Snapshots (image 1.11). Go to the bottom of the tab and click the "make new" icon, next to the trash (image 1.12) and name it (image 1.13). I can go back to full color version by unchecking the "Convert to Grayscale" box, and

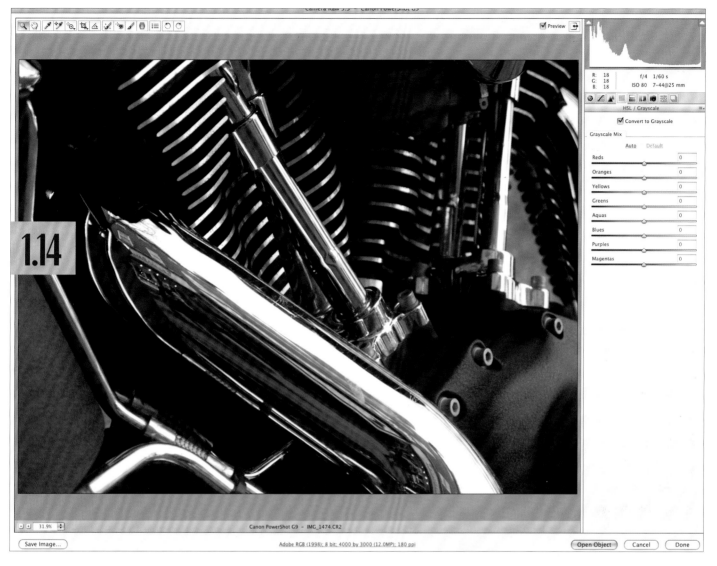

back again to the previous grayscale conversion—even if I've made changes—by hitting the Snapshot (image 1.14). (Another way to get there is through Image Settings>Apply Snapshot (image 1.15).)

Now I set up for the Smart Object process. I can see some areas I want to clean up on the motor, as well as my own reflection in the pipes (image 1.16). I hit those spots using the Retouch brush (image 1.17), and toggle the "Show Overlay" box off to hide the circles (image 1.18).

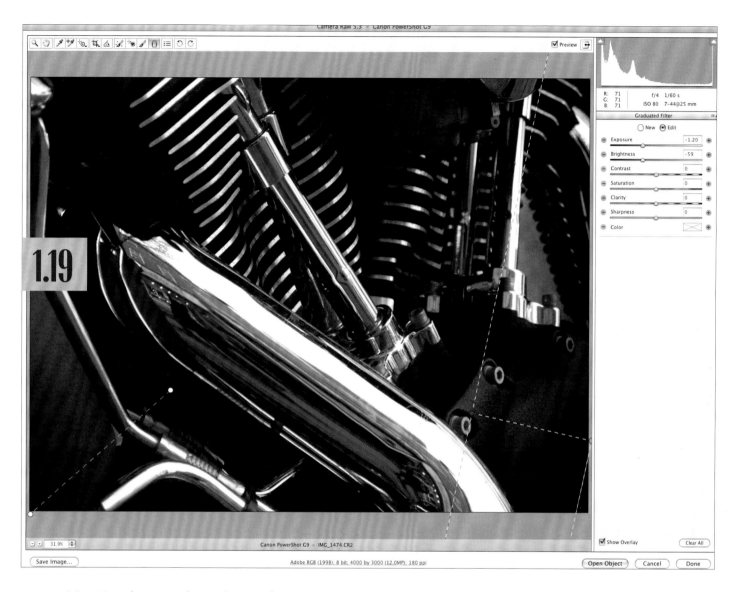

Now I make some basic burn adjustments using the Gradient tool (**image 1.19**). I darken it a bit on the lower left side and fine-tune on the right.

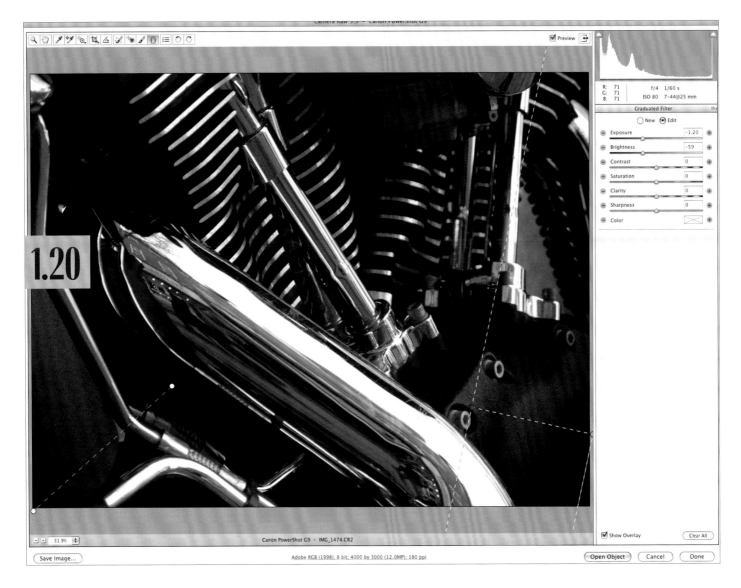

Then I hit "Open Object" and bring it into Pho-

toshop as a Smart Object RAW file (image 1.20).

Part Two: Processing in Photoshop

I start with an Unsharp Masking adjustment for a couple of reasons. First, there's nothing to lose doing this here because it is added as a Smart Filter and I can alter the settings anytime I want. Second, Unsharp Masking at this stage means that when I add Smart Object layers later, it will duplicate the filters too. (image 2.1 & 2.2)

2.3

I want to do some work on this, so I make a new layer: Later>Smart Object>New Smart Object via Copy (image 2.3). I double-click the Smart Object icon in the new layer to get back to the RAW image file and mess around with the settings. The striped reflections in the pipe are not really as I envisioned them; I'd like more separation in the tones there, so I adjust the red channel. (image 2.4)

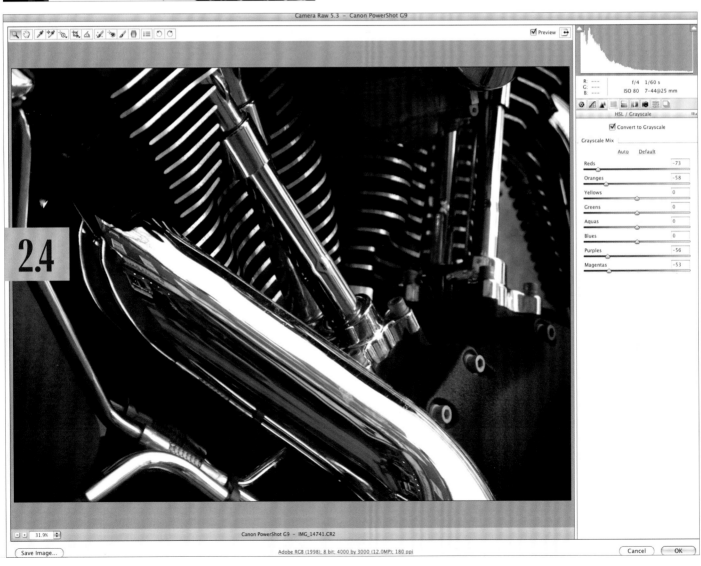

2.4

Take a close look. Before: (image 2.5) and after: (image 2.6). The lines are more defined because they are based on red tones, and I've pulled the red channel down. They were medium gray; now they're darker gray.

I want that to apply that only to one spot along the pipe, so I mask it. I hit the Mask icon (image 2.7) and get a transparent, white mask (image 2.8). I hit the keyboard shortcut Command+I to invert it to a black, opaque mask (image 2.9).

2.10

I use the Brush tool to paint white on the areas I want to show through (image 2.10).

Finally, I want to double-check how I've adjusted the image to see how the printer is going to handle this, so I open the step wedge file (image 2.11), select a part of it and hit Copy—Command+C (image 2.12).

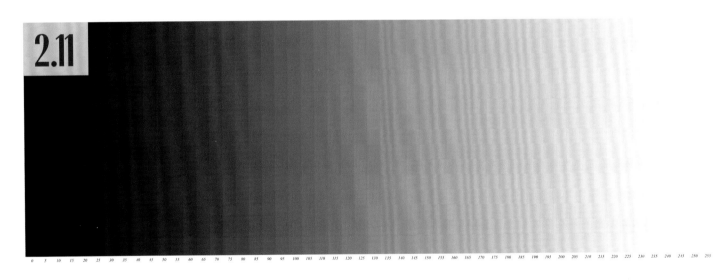

2.11

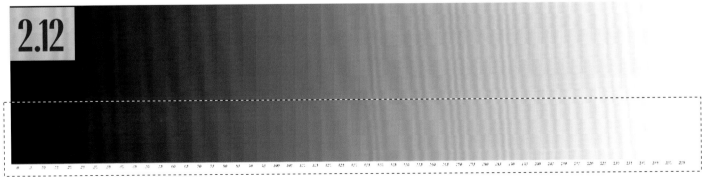

2.12

I go back to my working image, paste it—Command+V—and slide it around to check my shadows (image 2.13). Then I check my highlights (image 2.14).

Finally, I drop it in the middle and stand back
for a good look (image 2.15).

Here is what my final file looks like, with the
step target turned off (image 2.16).

2.17

I save it before I send it to the printer

(image 2.17).

Part 3: Printing

Work prints are an essential step in the process, a step that is often ignored in this WYSIWYG digital age. To paraphrase a student of mine, there's no way that looking into a light bulb—the monitor—is going to show you what a print is going to look like. Make prints, look at them, think about them, and then return to the file to get the most out of it.

After much testing and trying, I've decided to run the Cone Piezography K7 inks in my Epson R2400 with the QuadTone RIP and Innova paper: File>Print (image 3.1). This is an advanced print workflow, so refer back to page 131 for the discussion on printing with a full color ink jet printer.

3.2

In the main Photoshop Print window, I select the QuadTone RIP as my printer (QuadR2400-K7) (image 3.2). This tells the printer—actually, the RIP—to control the colors (image 3.3).

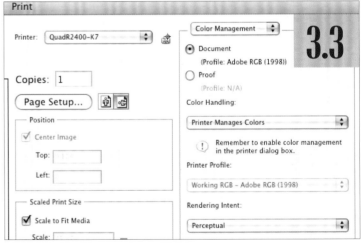

3.3

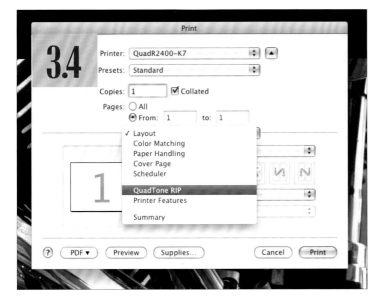

In the Printer driver window, I select the Quad-Tone RIP controls (image 3.4). This gives me the main RIP controls, and since I'm just using a basic, one-curve setup, I select the paper and inks as the primary curve, Curve 1 (image 3.5).

Here's the entire print window (image 3.6). I've made one little change: I've set the dpi to 2880, since I have a lot of time and I want to lay down some serious ink density on this paper.

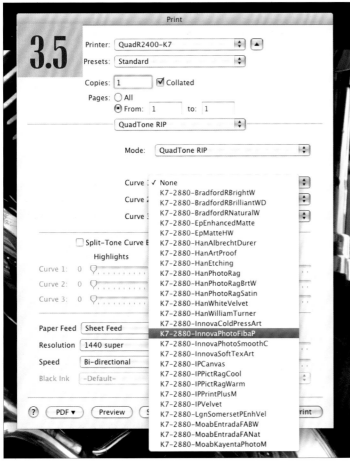

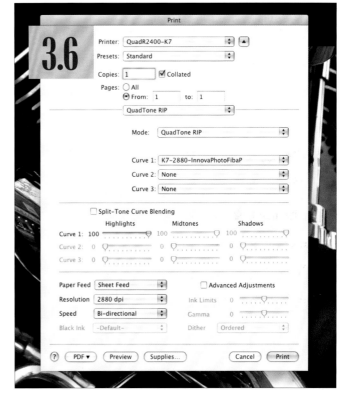

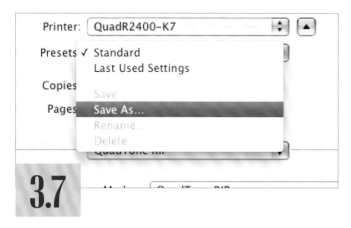

3.7

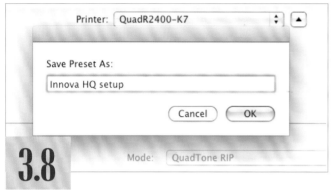

3.8

Now I could hit Print, but I want to do one last thing. Since this is a work print and perhaps the first of many, I'm going to save the settings. This is easier and faster, and lessens some of the margin for error. Hit the Presets pulldown, chose "Save As" (image 3.7), name it (image 3.8), and hit OK.

After you print the image, make sure to view it under the light source you're printing for, and maybe a few others. I hold my prints under my viewing light and up to a window; I'll wander around the studio or the house, trying out every different environment and light source I can. But the most important light source is the one that will be shown on the final print.

This seems like the end of the process, but in fact you've just started. At this point I might put the print aside and give my eyes a break. Your eyes want to adapt and accommodate, and your brain focuses on details to the point where you can't see objectively. I may not go back to a print for a week or more; this is easy when you're using Smart Objects and Layers, and have labeled your work as you go. Come back later, sit down to the file, take a look, and resume right where you left off.

One more tip: Use a marker and draw all over the work prints. As you look at them, and think about what you want to do and sketch that directly on the prints—they're work prints, after all. Another tip: Nothing is a liberating as a fresh start, and the fastest way to a fresh start is to physically rip bad prints up. Try it some time. It's a joy to take a print that's driving you crazy and just rip it up into tiny bitty pieces

There you have it. As I've said before, this one is mine—now go make your own. It is something I've settled on after lots of tests and tryouts, and it works for me. Run experiments and build your own process, but keep it simple and clean. The point of this process is learning to envision your final image and using the best tools available to create that vision.

APPENDIX

A lot of the "bricks and mortar" of our process presumes some other foundation skills which we don't go through in the main text. Some of it may be totally new to you, or it may be a little unfamiliar and all you need is a little refresher. Either way, what follows in the Appendix is intended to give you reference to the processes that work within the most effective workflow, however you choose to put that workflow together.

Keep in mind that much of what is discussed here briefly is also the subject of entire books. If you need more help or find something of particular interest, you can be sure there's a whole world of information out there. I've referenced other sources where possible, so dive in.

As my buddy Nick says, you can go down that rabbit hole if you want.

Camera Setup

There are some settings you should be aware of to make sure you're seeing the right information on your histogram. Even when shooting RAW files, the camera generates a very small JPG file—a thumbnail—that is shown on the camera's LCD monitor. The camera also uses that thumbnail to set up the histogram. If you have the camera set to your preferred color, contrast, saturation, and color space settings, then the histogram you're going to see is pretty close to what you'll get after you apply your post-processing. If you're like me, you might want to know what you will get for tonal information, not so much what the image will look like. Either way, it's crucial that you set your camera preferences.

You can find this menu is in the camera setup part of the menu. I'm showing you the menu from my little Canon G9, but every RAW-capable camera has these choices, and if you can't find them right away, dust off the manual or search it out online.

The settings on the G9 are under "My Color," then "Custom Color" (image A). From there I can get into the Contrast (image B), Sharpness (image C), and Saturation (image D) settings. I prefer to turn everything down, especially the Contrast, so I can see what I'm capturing in the file. If you consistently shoot for high contrast, for example, maybe you want to set this to high so the histogram will give you a prediction of your final file. Most D-SLR camera also have a Color Space setting; if you have it, set it to AdobeRGB to match up with the working color space in Photoshop.

Here are a couple of notes. First, remember you're shooting RAW files. It doesn't matter, in terms of processing, what your camera settings are—other than making sure you are shooting in RAW—because you can override anything you've done on the camera in the RAW processor. Second, you may see the black and white setting (image E). This makes a desaturated preview—some people like this. Again, you're not changing the RAW file and you can always reprocess it differently, so there's not processing reason not to do it, but I just prefer to leave my color preview on. My black and white preview happens in my head—visualizing the result—and not on the display.

Controlling the Histogram

This is all well and good, but how do you actually use and control your histogram? Control the histogram by controlling the exposure. You can use the manual exposure control or the shutter speed, aperture, and ISO controls to move the exposure up or down, thus moving the histogram up or down. You can also use one of the automatic exposure modes or the exposure value compensation (EV+/-) controls. Here's how that works.

I start off in Aperture Priority mode with a normal exposure (image A). Look at the histogram in the upper left corner of the preview. I have a white subject and my white values are high up on the scale. Remember my step wedge—I don't want the whites to touch or fall off the highlight edge of the graph because that means an abrupt step between the 250 and the 255 values. I like to be safe and move the tones down a bit. Now, looking at my shadows, I have some wiggle room, so I hit the EV +/- button (image B) and take the exposure down.

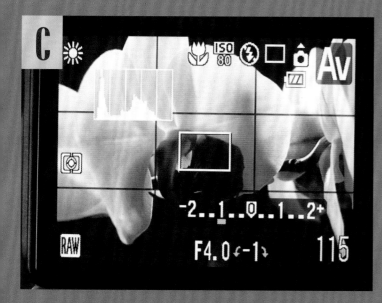

This is what happens when I knock the exposure down a full stop (*image C*). This is a helpful test to see what my highlights really look like and whether there are some that I hadn't seen before because they were totally off the scale.

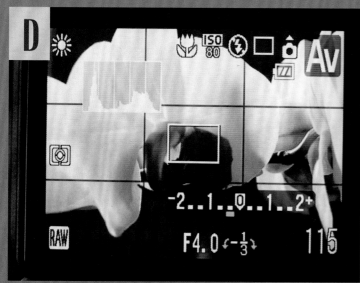

I'm now well within the comfort range, so I bump it back a bit (*image D*) to -1/3. The whites are within range and so are my blacks. I can also see that the image has a full range from black to white, which will serve me well for this image. I'm seeing a rich, deep black, some sparkling highlights, and some luminous mid-tones in the high gray values as I visualize the final print.

NOTE: Don't forget to reset the EV +/- dial to 0 after you take the shot. I'm embarrassed to say how many spontaneous grab shots I've messed up by having that set for the previous exposure.

CALIBRATING THE DISPLAY

Just a few years ago, calibration was more of an issue than it is today, but with the improvements in color performance of fairly common displays, and the drop in price for decent calibration systems, this has become a routine issue for most photographers. The big question, though, is usually what settings to use. Even that has settled down to an industry-standard answer.

Here's the starting screen in X-Rite's Eye-One Match software (*image A*). Note these three fields (*image B*). This is where you set the target values of your neutral balance (White point), your contrast response (Gamma), and your brightness (Luminance). This is what I suggest for an LCD display: White point – 6500, Gamma – 2.2, and Luminance – 120.

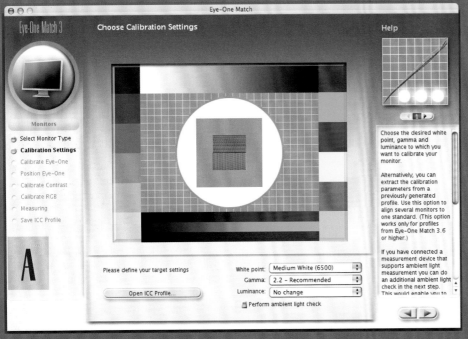

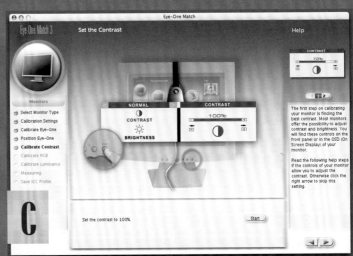

The process is pretty simple once you set those parameters, regardless of what software you choose. Next are the brightness and contrast adjustments, where the software measures the two values and gives you a meter to indicate whether you're on-target (*image C, D & E*). Finally are the color controls (*image F*). If you have a monitor that has separate R, G, and B controls, this control lets you dial in the values to match your target.

When you're done you get this (*image G*). This lets you name the profile you've built, and also shows you lots of cool and nerdy things about your monitor and the corrections that have been made.

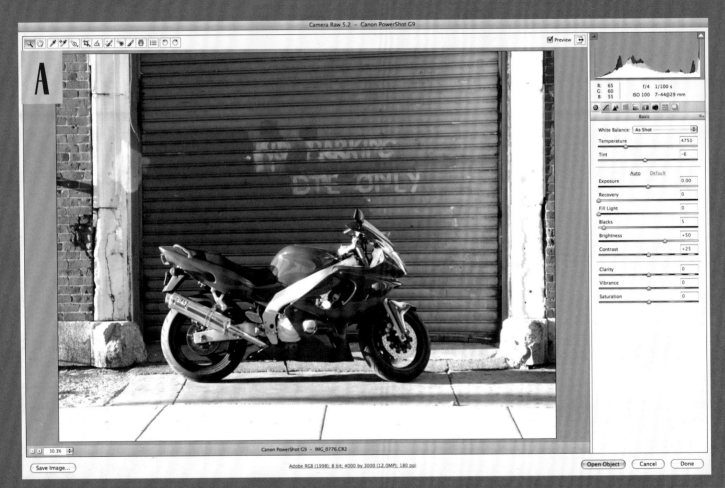

Camera RAW started as an addition to Photoshop—a plug-in, actually—and I think it was the main guy on the Photoshop team, Thomas Knoll, who said that some day Photoshop would be a plug-in to Camera RAW; that is how big it's going to be. With the addition of selective adjustment tools, and powerful ones at that, we are certainly starting to see down that road. My definitive primer on Camera RAW is found in Smart Object Pipeline, but here's a starter with my favorite pointers.

Basic Camera RAW Adjustments

Get to Camera RAW by opening a supported RAW file. If you get an error message that the file is unsupported, go to the Adobe site and check for an update. (www.adobe.com/support/downloads/new.jsp.) If your camera is really new, you may have to wait a bit for Adobe to get the proper camera support, but in most cases they respond pretty quickly. Read their instructions for the install and you won't go wrong.

Once you open the file, here's the main window (*image A*).

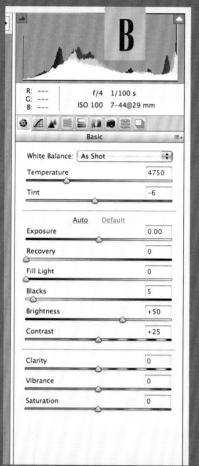

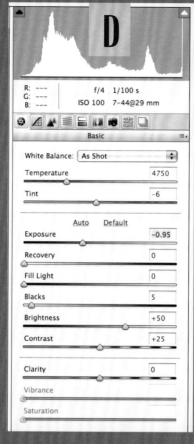

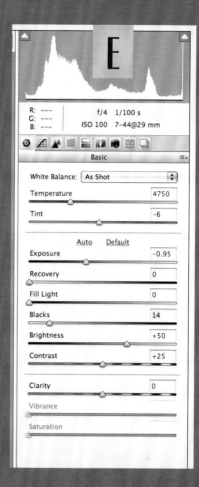

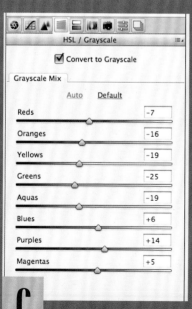

Your adjustments are all to the right (*image B*), and organized by tabs. The HSL/Grayscale tab is the one we're going to use most (*image C*), but we have t o set up a few things first. There are only three things I use from the Basic tab: Exposure, Blacks, and Brightness sliders. The Exposure slider controls the highlights, or the white point (*image D*). As you slide it around, notice that it moves the highlights on the histogram and stretches or compresses the other values to fit. That is a highlight clip, or setting the point where the highlights are cut off to pure white.

The other side of that is the shadow clip, and is controlled with the Blacks slider (*image E*). As I slide it, it moves the black values up and down over the 0 threshold—again, just stretching the in-between tones to fit.

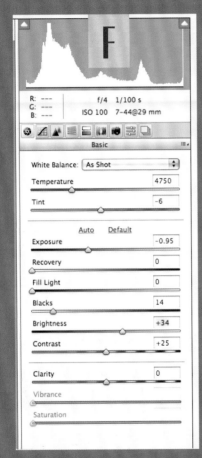

Finally, you have the midtones themselves, which are controlled with the Brightness slider (image F). You can see them moving around within the fixed highlight and shadow endpoints.

That is the basic Camera RAW process. Set the highlight point, set the shadow point, and adjust the midtones.

Synchronize Image Adjustments

Camera RAW allows you to apply adjustments to several files at a time. If you select and open a few files, you'll get a filmstrip on the left side (image A). I change this view to the active, visible frame (image B). Now I hit "Select All" at the top of the strip (image C), and then select Synchronize (image D). This gives you a huge list of all the things you can synchronize, along with some useful subsets in the pulldown menu (image E).

Other Useful Tools

The Spotting tool is pretty important, especially if you're working in the Smart Object workflow. It allows you to do any retouching directly in Camera RAW, without resorting to rasterizing your Smart Object later. Click it (image A) and you get the choice between Healing and Cloning (image B). These controls are a little different than the Heal and Clone tools in the Photoshop workspace, but with a little practice are every bit as useable.

The Adjustment Brush is an important tool (image C). Click this and you've opened up a new world of selective control—burning, dodging, and spot-color correction—in Camera RAW (image D). I could write an entire book about this; it can get pretty unwieldy fairly quickly. I'd suggest taking a stab at it, but don't get too carried away. The tool leaves little pushpins all over the image for you to reference (image E), and if you get carried away with it, it's easy to get confused.

That's a start. Dive in, pick your tools, and get to know them. One thing I'll say about Camera RAW at this point in its evolution: If you want to do something there, chances are you can. It's just a matter of figuring out how. Check out the Camera RAW Primer in Smart Object Pipeline for a complete roadmap if you want to know what's under the hood. But this should at least get you driving the car.

D

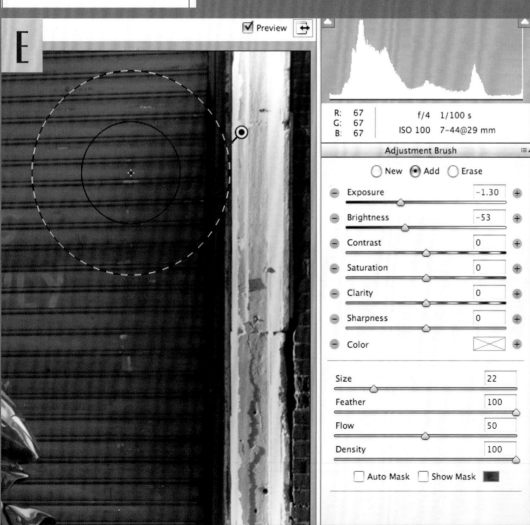

E

*W*orking with masks and layers is actually pretty simple; the hard part is learning how to do it. Let's look at an example of a mask in use.

My goal with this image is to mask out the gray sky in the background and make it pure white. The main image is sitting on top of and completely obscuring a white background I've dropped in (*image A*). This is my mask (*image B*). Relate this to film—the black areas don't let light through and the white areas are transparent. When I put this mask over my image, it will block out the sky in the image and the building will show through the white. Here's the result (*image C*).

Take a good look at the layers again. The background layer is solid white and the image layer is on top of that. The mask is on the image layer. The opaque areas of my mask— black—are blocking the image but not obscuring the white layer. The areas that let the building show through let the building image cover up the layer underneath.

Here is a different view (*image D*). This shows the building image on the bottom, the mask in the middle, and the resulting image on top. The resulting image shows that the masked areas are blocked.

Making and Editing Masks

If you're working on an adjustment layer, the Mask is automatically created. If you're working with an image layer or a Smart Object layer, you must make it. This icon is at the bottom of the Layer palette (*image A*). Select it and

it places a mask on the active layer (*image B*).

Editing a mask can be done several ways. One way is as simple as actually painting on the mask with the Brush tool choosing either black (for opaque) or white (for clear) on the foreground/background color selection area. Here's a quick

example: I add a white layer first and then my shot of Barbara (*image C*). Now I add a mask and paint on it with the Brush tool (*image D*). This is what my mask looks like now (*image E*). The white layer is sitting

under the image, obscured by it. The mask holds part of the image back, making it invisible and the white layer visible.

That is probably the most confusing part. The mask is indirectly affecting the layer beneath it. It's directly affecting the image or adjustment layer where it sits, but by controlling what is visible of it's own layer, it controls how much of the layer below is visible, too.

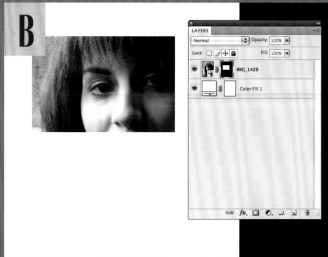

You can also make a mask by selection. In this example I've selected a rectangle (image A). Once I make the selection I hit the mask button (image B). I can use any of the selection tools in Photoshop to do this; any tool that makes a selection on an image will let me make a mask of that selection. Of all the tools, the Color Range tool may be my favorite because it lets me pick a particular color for masking. There's one more thing I have to tease you with, and that is the Mask Panel in Photoshop CS4. Windows>Masks will take you here (image C); this is a powerful and handy little control to modify and fine-tune the mask to suit your purpose.

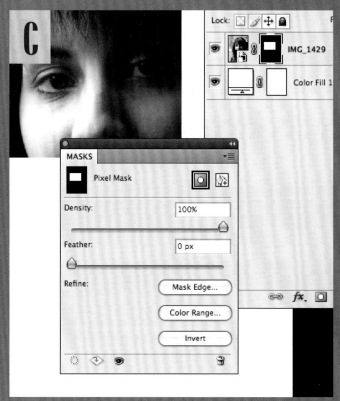

Masking Layers: Step by Step

Step 1. Prepare the Tools

Select the Brush tool and use these Brush Settings as a starting point: Mode – Normal, Opacity – 50%, Flow – 50%.

Go to the Color Picker icon, and set the Foreground/Background color to white/black by clicking the little black/white squares. The Default colors are a black foreground and white background. The two-headed arrow will switch the background and the foreground colors with one click. (Also, hitting "d" on the keyboard will set them to the Default colors.)

Layers Palette: Visible. (Window>Layers checked)

Step 2. Create the Layer and the Mask

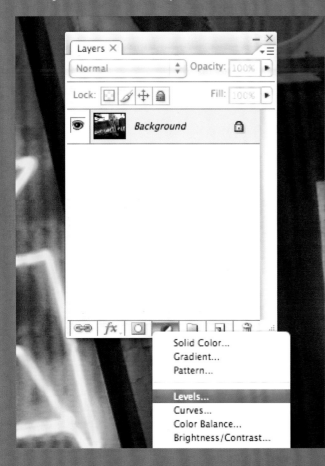

Select the black/white circle at the bottom of the Layers Palette—"Create new fill or adjustment layer," and make an adjustment. Here, I'm selecting the Levels adjustment, and making the image darker.

Select the adjustment layer's mask. This is the white rectangle next to the Adjustment icon, in this case, the "Levels." The mask is made automatically when you create an adjustment layer. Now, turn your mask black with keyboard shortcut Command+I.

Step 3. Make the Mask Selection

With the now black mask selected, use the Brush tool to "paint" white on the areas of the mask where you want the image to be visible, or active. This shows a small area of our adjustment that will show through. If the adjustment makes the image darker, this is the only area that will be darker, and vice versa.

Tips

"{" and "}" make your Brush smaller and larger in diameter.

"x" switches the foreground/background colors.

"Painting" black over a white area of the mask covers the edit, allowing you to fix or change the selection.

The "Opacity" percentage on the Layers palette (different from the "Opacity setting for the Brush Tool") allows you to decrease the overall effect of the adjustment layer.

The Smart Object Pipeline *has the most detailed explanation and demonstrations of Masks and Layers, and if you want to hear it from a different source, read Katrin Eisman's book* Layers and Masking.

Let me begin by saying that after you give a fair portion of time to a project like the Smart Object Pipeline and put over 250 pages together on one subject, the idea of condensing that into a few pages is daunting. That said, here it is.

First, what is a Smart Object? It's a way for you to get back to the RAW image process. Once you process the RAW file, you can't really go back if it's not a Smart Object. Of course, you can process the RAW file again, but you have to make a new file. The Smart Object lets you get back to that processed RAW file and make changes. Technically speaking, the Smart Object is that RAW file imported into Photoshop as a layer. Because it is a layer, it has all the properties of a layer. It has opacity, blending modes, and most importantly, masking. It really is as simple as that.

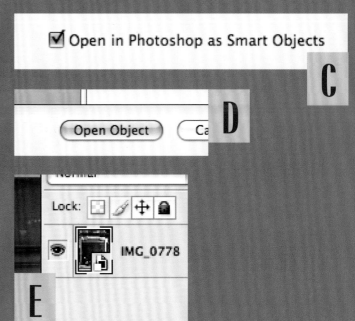

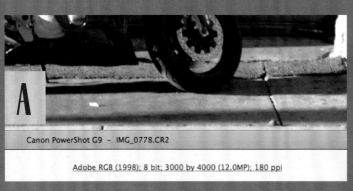

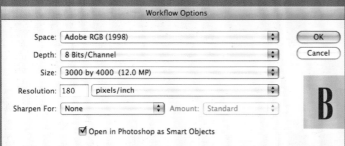

In Adobe Camera RAW, start by clicking the Workflow Options link at the bottom (*image A*). This will open the Options dialog (*image B*). Check the box "Open in Photoshop as Smart Objects" (*image C*). This will switch the "Open" button to "Open Object" (*image D*). When I select "Open Object," I get a layer with this icon (*image E*). Now, any time I double-click that icon I can get right back to the processed RAW file in Camera RAW and I can reprocess it as many times as I want.

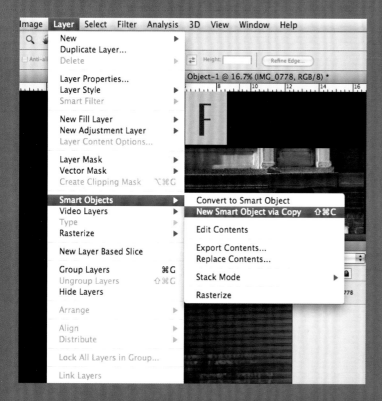

I can easily make another Smart Object from this image, but not through the normal "Duplicate Layer" button. That will make a Smart Object layer that is linked to the original Smart Object; anything you do to one will affect the other. Making another independent Smart Object layer is very simple: go to Layers>Smart Objects>New Smart Object via Copy (*image F*). That generates a new duplicate layer, linked only to the RAW file and not the original Smart Object layer (*image G*).

Smart Filters

Now let's look at Smart Filters. If I'm working on a Smart Object and open a filter, it is automatically converted into a Smart Filter. A Smart Filter is a filter that you can readjust it after it's applied (*image A*). Here I'm applying an Unsharp Mask filter, (*image B*). If I double-click that filter, it reopens up the dialog, and I change the filter settings.

If I make a new Smart Object after I've applied a filter to the original Smart Object layer, the copy will have a duplicate Smart Filter as well as the unlinked copy of my Smart Object (*image C*). Add a few adjustments and a mask or two (*image D*), and you have a layered file of RAW images, filters, and selections that are infinitely modifiable.

This is now the cornerstone of the so-called "non-destructive" or "constructive" Photoshop workflow. It is nice to be able to apply adjustments as layers, and always have the original information on the background image, but that doesn't change the fact that making an adjustment—any adjustment—is a destructive process. Building RAW files on top of each other is a constructive process. You're adding a new image with every layer, like stacking transparencies, and masking the pieces of each layer to completely control your final image.

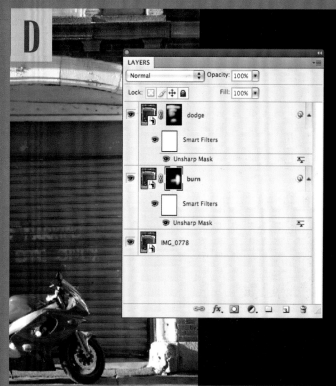

CUSTOM KEYBOARD SHORTCUTS

There are many processes in Photoshop that are repetitive and time consuming. If it's a true process—that is, a consistent series of commands—I often create an Action to run the sequence for me. If it's just one command, I can make a customized keyboard shortcut for it.

Making a copy of a Smart Object layer is just that kind of a pain. Go to Layers, and then Smart Objects>New Smart Object via Copy (image A). This is a perfect spot for a custom keyboard shortcut.

Here is how we create our own keyboard shortcut: Go to Edit>Keyboard Shortcuts (image B). Here's what you'll see (image C). Find the command that does what you want it to do. For me, it's Layers>Smart Objects>New Smart Object via Copy.

Once you've found it, just select it. There is a little window that lets you put in your choice. If it conflicts with something that is already set up, you'll get a notice of the conflict and you can accept it or change it. Since I never "Copy Merged," I click "OK" and accept the "conflict."

Now when I make a new Smart Object layer I hit Command+Shift+C.

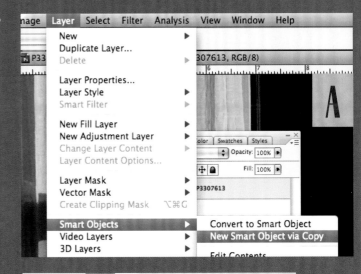

DEDICATED BLACK-AND-WHITE DIGITAL CAMERAS

It won't take long before it occurs to you that a digital sensor is natively black-and-white, but with color filters added to create an RGB color image. We are throwing the color information away and going back to the black and white. Why not start with a black and white sensor and no color filtration?

There have been a few versions of a dedicated monochrome cameras offered by a handful of manufacturers. Mega-Vision (before they all but faded from the medium format digital back scene), offered the E-Series Monochrome back, available up to 39MP. Phase One produced the P45 monochrome sensor

for Bear Images (www.bearimages.com) in San Francisco. Around 2002, Kodak released the DCS 760m, a monochrome modification of their Nikon F5-based flagship D-SLR.

Obviously, the thing we don't get is color. This lets the "film"—or in this case, the silicon and analog-to-digital (A/D) processor—make the transition from color to luminance with no direct control from the photographer.

As a black-and-white photographer, this puts you somewhere between settling for film and it's quirks and characteristics, and the options, control, and extra processing of a three-color file. Add to that a fairly hefty price tag for a camera that is less flexible (in an age where everyone wants everything), with the rapidly increasing resolution and low noise of the D-SLR market, and I'm fairly certain that this is a platform that, although interesting, probably doesn't have much significance beyond some hard-core devotees.

These cameras have some pretty profound advantages, as well as some equally profound disadvantages. Because they don't have a color filter between the lens and the pixel, they receive more light and are therefore more sensitive. Also, because they don't demosaic the three colors (RGB) with in-camera processing, each individual pixel site on the sensor builds a corresponding pixel in the image, and results in better actual resolution. Some claim you get twice the real resolving power—not an insignificant claim. Also, because there is no Bayer Array on the sensor, color aliasing and moiré problems do not exist.

TRACKING COLOR:
PREVIEW, SNAPSHOTS & LAYER VISIBILITY

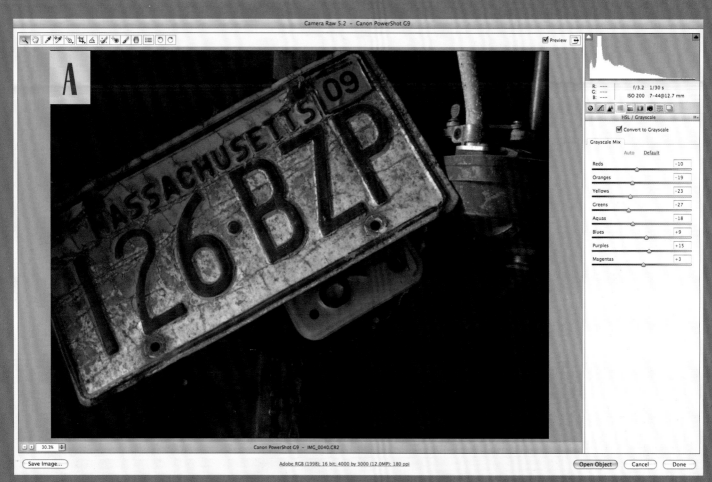

Converting colors to gray values is an important part of creating black-and-white images, but when you're deep into using your preferred conversion method, it's easy to lose sight of what the original colors were. If you want to adjust the original color value of a converted grayscale tone, how do you find that original color?

Preview

If you're converting color into grayscale with Camera RAW, finding a color tone is a matter of toggling off the "Preview" mode. I've lost track of the original colors in this grayscale image (*image A*). Simply uncheck the Preview button in the upper right corner of the main window (*image B*), or hit the "p" key to get to the original file view.

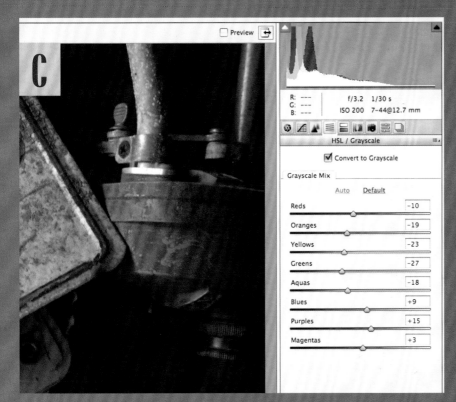

Now I can target a particular color (*image C*). I want this to be darker, so I track my reds down a bit (*image D*).

Snapshots

Snapshots (introduced in Camera RAW 5.2) is a simple device that allows you to look at a few image variations, including the original color (image A). Select this tab, and then the "new" icon (image B). Use this to save and go back to any variation you want to compare (image C); this is stored in the Smart Object along with everything else.

Layer Visibility

If you're using any layer-based editing method, finding the source color is a small matter of activating or de-activating the layer or filter. Every layer has a little eye icon next to it (image A); this determines whether the layer or filter is visible or not. Toggling that on and off turns the adjustment on and off without changing or erasing it. This is the layer palette with the adjustment turned off (image B).

INDEX